CONTENTS

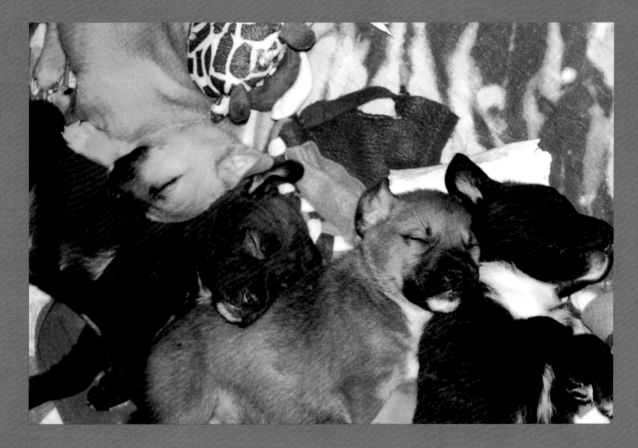

PUPPY ART

That's Pepper, Chili, Curry, and Nutmeg. I didn't pose them. If you hang out long enough, this awesome stuff happens by itself. Every day.

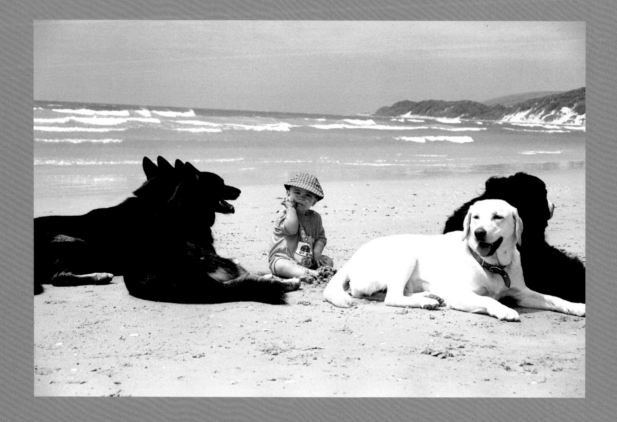

THE SPIRIT OF THE PACK

Something extraordinary happens at our house: Foster pups come here in turmoil, and the spirit of this pack settles them.

More than twenty years ago, our original four dogs welcomed our first baby, Grace, with generosity and warmth. It was an early moment in the creation of what now feels like our pack's collective soul, passed from dog to dog over time until it seems we've just had one deeply melded, ageless pack. I feel that grounded, wise spirit at work every day in this house.

It's okay, you can say it. *Crazy. Dog. Lady.*

Once upon a time, I would have agreed with you, but that was before I had lived in a pack.

Introduction

LIGHT A CANDLE

They are two weeks old. So far, their whole world has been smell and touch: their mama's belly, their littermates' warmth. Soon they will begin to see and hear — and I get to shape the world that greets them.

This scenario plays out again and again in our lucky house.

Thanks to a whole lot of people who work to get unwanted puppies out of danger and into foster care, pups land with us and experience an environment that nurtures their little souls. With each calm voice, each gentle touch, each happy interaction, we teach them to anticipate joy. Then we send them out to create some.

What's that worth?

Does it even matter?

In a world filled with so much human suffering, does it make a difference to save a puppy?

It certainly matters to that puppy. What a gift to be able to do just that.

I'd wager it matters to the family who eventually can't imagine their life without that special dog.

Come to think of it, I'd say that it matters to the people who stop me in the grocery store, delighting in the latest antics of our newest pups, everyone knowing there's a happy ending in sight.

I'd even suggest that it matters to the random acquaintances who tell me they go to my Facebook page when they're feeling stressed because it reminds them that there's good all around us.

I think in a decade or two it'll matter to the puppies who get taken in by all the kids who streamed through this house to see pups and decided to foster when they grew up.

I know they're "just" dogs, but by taking them in, I like to think there's a ripple effect.

We all have the choice of whether to sit around and curse the darkness or to light a candle.

This sure is a fun candle to light.

HOW IT ALL STARTED

Zoe put us on the path to fostering. She died, and we were heartbroken. I knew we needed new life in our house, but we weren't ready to "replace" her. Somebody suggested fostering…

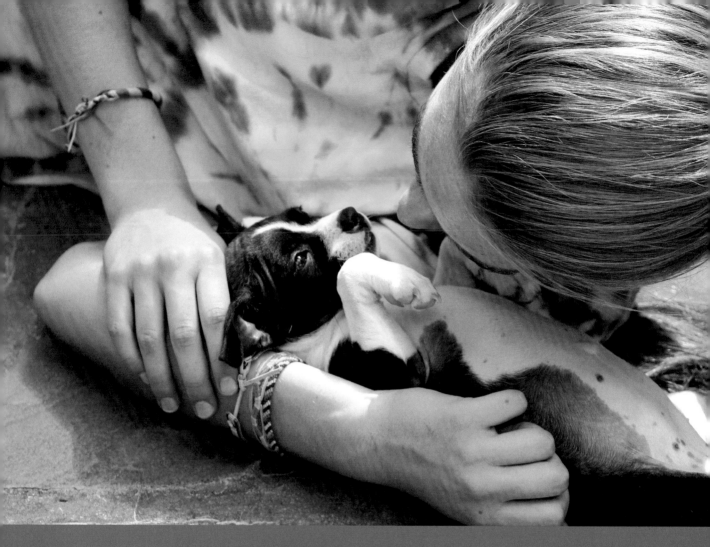

THE FIRST ONE

"Give us puppies we won't like," I said. It was our first time fostering. We were afraid of getting too attached. So they gave a tiny Boston terrier to the family that loved big dogs. Here's our daughter Grace with MoonPie. Oops.

THE POWER OF ELI

Tiny MoonPie was the first foster to claim this best of all possible spots. When a confused rescue pup arrives after a big journey to our house, our massive, gentle Eli can convey in an instant what would take the rest of us days: You're safe, it's good here.

Chapter 1

THE FIRST LITTER

It was shocking how quickly it became normal — and even "just right" — to have ten dogs living in my house.

Of course, we'd always had more dogs than most folks. Tom and I had three dogs between us when we got married, and our daughters grew up surrounded by pets. But when our dog Zoe died, we just weren't ready to find a new pack member. We decided to foster instead.

In those first six months, we dipped a toe in. We fostered five dogs, each for a few weeks. We got the hang of it, and even began to master saying goodbye.

Then in April, there was a fateful post on Facebook. Somebody had surrendered a mother dog, Nala, and her less-than-a-month-old pups at the local shelter. The family needed a foster, pronto. Puppies this young are at terrible risk for disease at any shelter because of their undeveloped immune systems.

I looked at Nala's face in that photo. I thought about that exhausted nursing mom who'd been caring for those seven puppies around the clock, only to find herself suddenly homeless. A lot of terrible things happen in life, and I can't do a darned thing about most of them. It struck me that this was a tiny little tragedy in my corner of the world that our family could remedy. We

Our two cats and two dogs were fascinated with the puppies — and vice versa.

contacted the shelter, and the next day our family hit an all-time high with ten dogs, two cats, and two fish on the premises.

I won't lie: I did not anticipate that fostering Nala and her pups would become a full-time job. But the truth is that I'd never had more fun.

The day after we said yes, Tom and I found ourselves at the shelter with our giant van. Smiling people were loading supplies — so many supplies! — into the back and relating bits and pieces of the story. Mind you, a litter's rescue story is sometimes like the old game of telephone. The gist of it was that Nala had been loved, but her pregnancy was unintended, and the puppies were simply too much for her owners to handle.

On the drive home, Tom and I planned our approach. Mama dogs are famously protective, so we anticipated having a bit of difficulty handling Nala and the pups. We had prepared to set them up in a makeshift den in our finished basement, intending to give them some space. We assumed we'd need to spend quite some time earning Nala's trust before attempting to handle the pups.

Not so much.

About three minutes after arriving on our property, Nala visibly exhaled. Every bone in her body loosened and the wagging began, as did the nudging for petting, and finally: *Oh, sure, you can snuggle them; actually, could you watch them for a minute while I hang out with the Man?*

My husband is catnip to dogs.

That human-interaction hurdle delightfully cleared, we still assumed we'd need to stick to our plan of keeping our dogs Eli and Rocket far from Nala and the pups.

Nala had a different concept. She took a look at those big male dogs staring from the

window and...happily swished her tail. All sorts of body language indicated she was utterly relaxed, even eager. Stunned at her goodwill, I put Eli and Rocket on lead and brought them out near the pen. More wags, and a gentle reach toward a sniff. Then a nap. In a photo taken an hour after her arrival, she's on the other side of the pen, snuggling with Tom, while her babies snooze inches from Eli. She wasn't irresponsible. She just knew.

What followed were five miraculous weeks enjoyed by four humans, ten dogs, and two cats, who were all fascinated by one another. I had not even dreamed we could have this intermingled joy. I had pictured us humans visiting Nala and the pups in the basement, while our

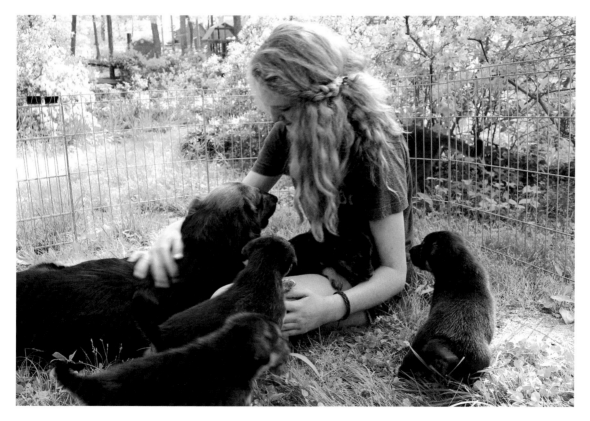

Nala was utterly relaxed with our daughter Claire, even in that very first hour with us.

own pets went about their normal lives in the rest of the house. Instead, Nala loved our dogs and cats, delighted in hanging upstairs with our pack, and even slept in bed with us from the very first night. She'd pop down into the "puppy den" whenever she wished, nursing, cleaning, and playing with the pups. Because the weather was glorious, we often brought all of the puppies out into the backyard, where Nala happily allowed our dogs and cats to interact with them.

Being around a litter of puppies for an hour is always the same: They're darling, they're crawling all over you, and you can't help but laugh. What was strikingly new to me with Nala's litter was the intimacy and, I'll just say it, friendship that came with living together. We knew each and every one of those puppies and — a surprisingly sweet kicker — they knew us right back.

PRETTY GIRL: Her markings were so perfect she looked like a paint-by-number dog, but the most compelling thing about her was her leadership. She was out front every time, first to greet any new situation, always confident.

HELGA: The comic relief of the litter, this giant girl would suddenly catapult herself across the group from time to time. Prone to vocalizing with little grunts and squeals, she was often the first to come over for a snuggle.

LITTLE BEN: This sweet runt of the litter was at one point so sick the vet told me to prepare myself because "they have to have the will to live." WHAT?!? Tom and I both felt there was a phase where we saw him leaving us, gazing into some otherworldly sphere. Dang it, I didn't want him going anywhere, and after a week of obsessive care, he perked up. He turned out to be full of charisma and the biggest cuddler of the bunch.

SPECKLE BOY: This is the guy you want your daughter to marry. As steady as they come. Not out front, not lagging behind. Just always taking part in things with a great smile and so much warmth.

SPECKLE GIRL: This adventurous spirit was constantly exploring, thinking, and figuring things out — the future astronaut of the family.

SWEETIE PIE LOVE GIRL: This litter had been given a color theme by the shelter, so officially the pups had names like Amber and Cobalt. We couldn't for the life of us keep those names straight, and we found ourselves calling them what they looked like to us. Those silly

names stuck. This particular little girl had no obvious features that struck us in those first hours, so we named her last. We felt a little bad about that, so we gave her a name to reassure her that, although she was last, she was in no way least. Amusingly enough, Sweetie Pie Love Girl was the very first puppy chosen on adoption day.

FLUFFY: This gorgeous girl with a lush, soft coat was always either wrestling madly or sitting quietly alone, so very obviously content with her own company.

It was wildly exciting to see these individual souls just explode with growth and development right before our eyes. I remember contemplating where these eight dogs would have been — emotionally, physically, developmentally — if they'd been stuck in a loud dog run instead of nestled at our house at this tender time.

I think my fate was sealed right there, in that thought.

While we'd gotten a bit of experience "letting go" with our first few fosters, this goodbye was on another level. After five weeks with Nala's family, we were emotionally entangled as never before. Making it even more challenging, the public shelter required us to leave the pups there on a Wednesday night prior to being put up for adoption on Saturday morning. Even now, I can't stand to think about those three days when they were sitting in a concrete pen, terrified.

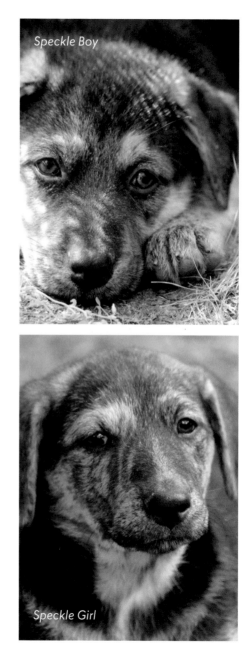

Speckle Boy

Speckle Girl

I hated the fact that — in contrast to what I'd enjoyed with our first five fosters, who came through a private organization called Homeward Trails Animal Rescue — there could be no looking these adopters in the eye, and no reassuring "after" photos in my email in-box. This time, we would have no idea who adopted our babies.

The saving grace of that period was that my anguish prompted Tom to say the three words that have now comforted me through the letting go of 150-plus beloved puppies: "Trust the dogs."

The second he said it, I knew he was right. I had done a lot of thinking about how fostering rather dramatically builds faith — in people, in the universe — but the last bit hadn't clicked into place for me yet. You have to have faith in the dogs themselves. They can complete that last lap of the relay, securing the all-important love that'll keep them safe forever. Just by being themselves, they can make it all turn out right.

I took some deep breaths, trusted the puppies, and said goodbye to our first litter.

Almost a year earlier, as our family was considering the idea of fostering, Tom's one stipulation was that we'd agree never to adopt a foster. He felt that if we opened that door, every single dog we took in would result in a roller coaster of emotion: *Is this the one?*

He was so right. It made so much sense. We all agreed. No adopting fosters.

See that beautiful shot of Nala at the start of this chapter (p. xiv)? That's her at the beach with us, after we adopted her.

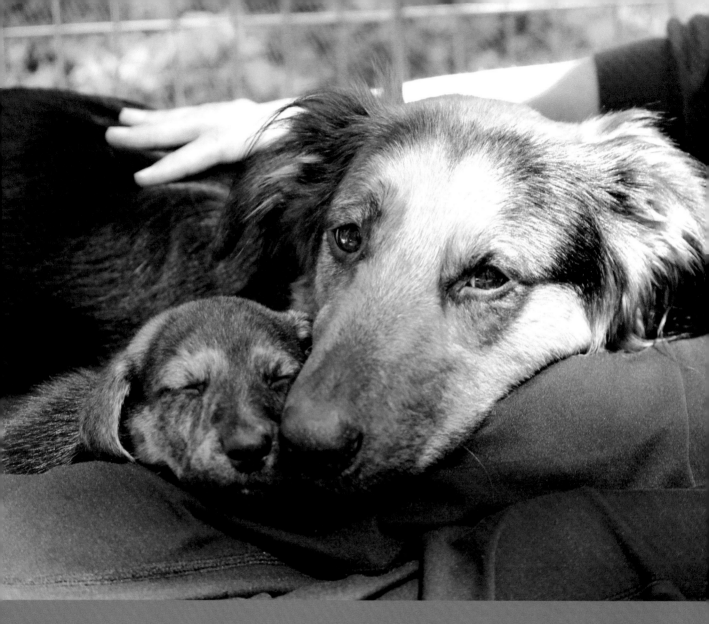

A MOM AND HER BABY

This is Nala, snuggling her daughter. I'm not sure how something so commonplace can be so extraordinary to witness. But it is. Every time.

THOSE AWKWARD TEENAGE YEARS

As kids reach high school, it can become a struggle to connect. It can be harder to find movies you can all watch, conversations you're all interested in, activities that don't meet a rolled teenage eye. May I suggest fostering a litter of puppies? You will all be interested. It's better than any movie. You'll never run out of things to say.

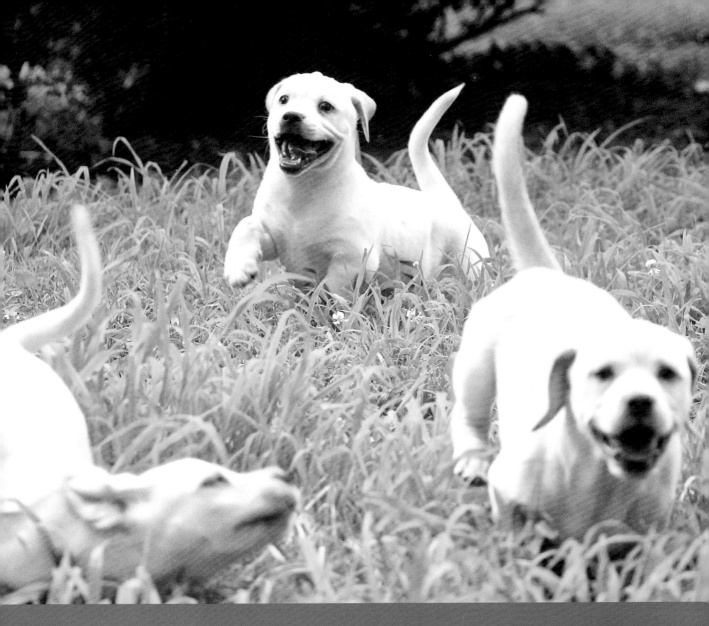

SPLENDOR IN THE GRASS

*First, there's the hesitation. The raised paw, the stillness. Then…
this. I love watching pups like Teddi, Jackson, and Lincoln
experiencing grass for the first time.*

Chapter 2

THE ONE KID WHO DIDN'T WANT A PUPPY

Every kid who comes to this house wants a puppy. They stream in, dragging their parents, making a shrieking beeline for the puppies. Next come the promises about caretaking, often some clever bargaining, and finally the begging.

That didn't happen with Matt. He barely even looked at the puppy.

He and his mom, Amy, had come to meet little three-month-old Twinkle. As they walked through the back gate, Amy was immediately all about the pup. She was on the ground, surprised and thrilled by Twinkle's warm greeting. In contrast, her eleven-year-old son seemed to be interested in anything but the dog. To be fair, we have a yard that's fairly distracting for any kid (swings, a trampoline, a hammock), but it is just unheard of for a boy that age to practically ignore a Real Live Puppy.

I wondered what was up.

It certainly wasn't Twinkle's fault. That dog was just priceless. She came to us by herself — no littermates — and had easily wagged her way into our pack in the month she'd been with us. She was a tiny blond "pointy" (as opposed to a dog with floppy ears) who loved to snuggle with us and hang with our big dogs. She was fun and engaged without being overenergetic or

too mouthy. Very quickly, Twinkle earned rave reviews from every member of this household. Perhaps most remarkable was her delightful relationship with our cat Wolfie. We were regularly treated to gentle cat/puppy wrestling sessions. While Wolfie was always interested in our puppies, we'd never seen such a personal friendship develop.

Yet this boy was unmoved by this perfect little pup. We were sitting around out back that summer day, letting things take their course. Often the rightness of a match — or the lack of it — becomes clear if you give it an hour in the yard. Eventually Matt piped up: "I'm kind of worried about my cat. I don't want my cat to be sad."

Ah ha. There it was.

With that one utterance I had the answer to the mystery, and this dear boy had my utmost respect. So very many kids — most, I'd say — only have eyes for the new puppy. Their current pet pales in comparison to the shiny new one.

Yet here was this kid, only eleven, with the heart to place his empathy for his old cat above his desire for a new puppy. That's the kid I wanted to raise my foster pup.

When Matt was out of earshot, I heard a bit from Amy about why she was seeking a dog.

Our dog Rocket working hard to teach mini-me Twinkle how to properly lie on the couch

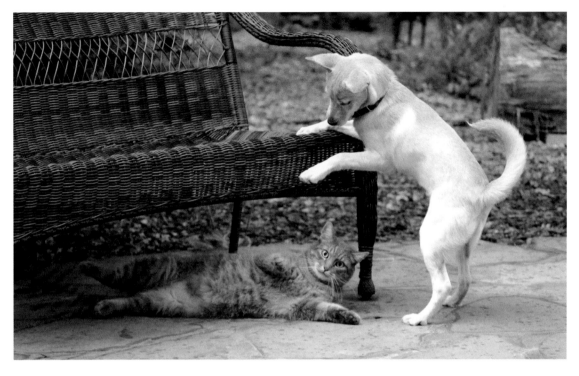

Wolfie and Twinkle, caught midgame

She talked with self-deprecation about how they were "somewhat older" parents, with Matt their late-in-life gift. She spoke of his approaching teenage years and increasing screen time. She worried her boy was on the cusp of an era of loneliness. That sure spoke to me, as it would to any mom. I felt deeply that Amy was on the right track: A dog would offer a path and a balm through the coming years.

I went over to talk cats and dogs with Matt. I chatted about why our family has always loved having cats and dogs together, how funny it is to see them interact, and why we think they enrich each other's lives. We discussed how to introduce a cat and a puppy safely. Of course, I also explained that this particular puppy already had a best friend who happened to be a cat.

Amy said that's what sealed the deal.

Matt and his dog, Twinkle, entwined as always

Soon I got the first of many boy-and-puppy photos, and even now, years later, I still adore the stunning shots that Amy sends via text every now and then, always with a line like, "They are inseparable." This is the dog of his lifetime, and he will never be the same.

There is a little asterisk to this story about fate…

Two weeks into our fostering of Twinkle, a very nice retired lady came to meet her. It appeared to me she'd be incredibly devoted to this new pup. However, by the time we got through the other steps in the process, the adoption ended up falling through.

That episode is one of the reasons Twinkle was still at our house when Matt's family started their puppy search. We had shooed away other applicants when we thought we had the right adopter, and Amy and Matt swooped in just at the right time.

Twinkle's story is why I breathe easy with our fostering, even when there are bumps in the road. Things, I've learned, work out. This was Matt's dog, and the universe conspired to make it so.

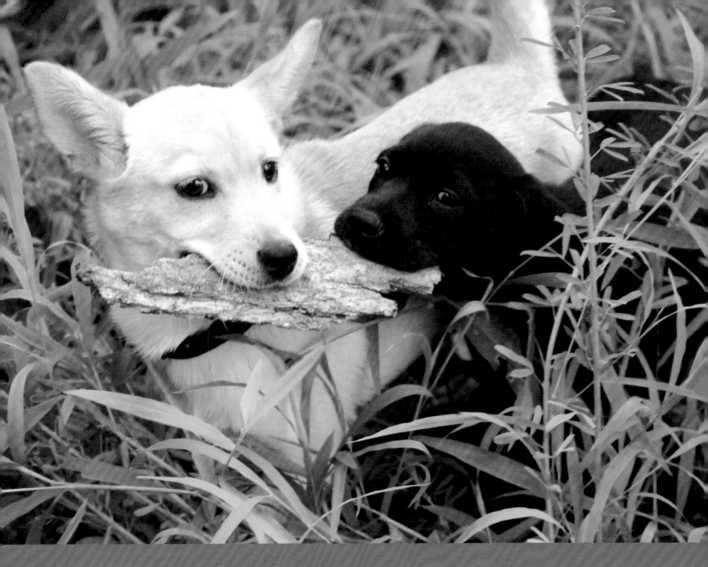

SUMMER CAMP FRIENDS

Sometimes we have pups — like Twinkle and Aladdin — who land here separately. Whatever their histories, they end up together at our house and instantly bond. They explore the yard as a team, play chase and tug, and sleep snuggled up tight. Like best friends at summer camp, they give each other confidence and comfort at just the right time … and then head off, both enriched by the experience.

COW PUPPY

Some dogs just have charisma. "Cow Puppy" so captured the imagination of one New Jersey family that they drove seven hours through an ice storm to meet him. They just knew he was theirs.

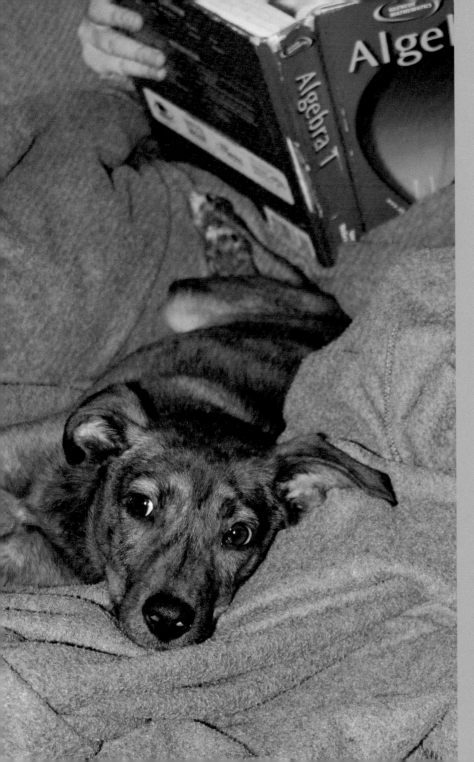

BELIEVE IT OR NOT, THIS IS THE WORK

One of the best things about fostering is that you can do a bang-up job of it while just going about your business. Here, Claire may have been learning algebra, but Frankie was learning even bigger lessons about humans, comfort, and trust.

Chapter 3

THE DOG WHO SEEMED EASY

In hindsight it seems hard to believe, but I honestly had no idea that Lulu was a difficult dog.

Thank goodness.

Had I known, I never would have placed her with the person who turned out to be her soul mate.

The first photo I saw of Lulu included her five six-week-old puppies. They were the cutest six-week-old puppies I had ever seen — and I have seen quite a lot of six-week-old puppies. Lucky for me, this fluffy little family needed a foster.

While it was the pups who drew me, Lulu herself was quite a knockout — an absolutely charming, border collie–looking bundle of fun. She popped into our house — five babies in tow — and acted like she'd known us forever. No issues with us, our dogs, our yard, our house. She immediately made it clear she knew she was welcome. We had an endless stream of enthusiastic visitors, and Lulu happily greeted them all, generously sharing her puppies, who were all adopted within two weeks.

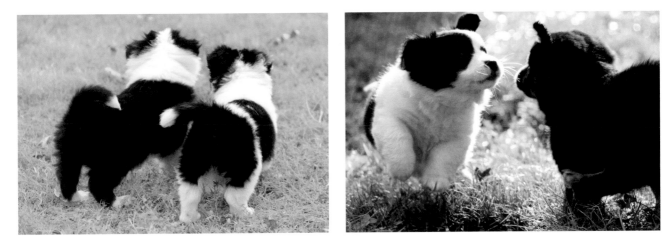

Lulu's five adorable pups were perfect stuffed animals come to life.

One of those visitors was Kathy, a retired teacher. She was the neighbor of a friend of mine, and the two of them walked two miles together every morning. Kathy had been looking for the right new dog, and she fell hard for Lulu. She was all in.

Alas, later that day, I learned that Lulu had just been promised by the rescue group to another adopter, one who planned to use her as a therapy dog in her school. I had to break it to Kathy, who emailed back: "I am trying to be a good sport knowing she will enrich a lot of lives in that role, but I'll have to wait until spring to try to find another dog. I need time to get over her."

Oh, man. I had broken her heart. I felt terrible, but it was a done deal and I had to move on.

The smiling young adopter who came to pick up Lulu was engaging and kind. She worked in a Washington, DC, charter school, and she felt the kids could benefit from a friendly dog's presence. My adoption coordinator had suspected Lulu would excel at that challenging work, and from what I'd seen, I agreed: She was warm, interested in new people, a big fan of attention, and not nervous, mouthy, or jumpy. I gave the nice lady my good wishes and hugged Lulu goodbye.

Well.

That duo was back at my door three days later. The young woman had bags under her eyes and her beautiful smile was nowhere to be seen. It seemed she couldn't unload Lulu fast

enough. I listened as she distractedly assembled a pile of brand-new items — crate, bed, harness, collar, leash, toys, and dishes — on my floor, like an offering. There was talk about a carpet being ripped to shreds and a scratched-up door. She said something about no crate being able to contain "this dog."

I was tempted to debate because our family had lived easily with Lulu for a month! However, in the end, the only important thing was that it was a no-go, and you never want an animal in that situation.

I welcomed Lulu back. As I mulled over this failed placement, I focused on the fact that the well-intentioned adopter was a first-time dog owner, living alone, and trying to take a brand-new dog with her to all her activities, including work. That was a high bar. I told myself it wasn't really a shock that she felt in over her head.

Thrilled I had such a gift to bestow, I called Kathy. She was over the moon. I was honestly delighted that the previous woman had flaked out because *this* was the match I had wanted.

Be careful what you wish for.

I soon learned that the first adopter wasn't a flake. It became obvious that, contrary to what I'd experienced, Lulu was a tremendously difficult dog.

Separation anxiety is the one thing that doesn't rear its ugly head at my house because, frankly, we simply have too many bodies. However, Kathy lived alone, with no other pets — like the previous adopter. When she left Lulu at home by herself, all hell broke loose. There was household destruction, crate escape, and howling, barking, panting, slobbering misery.

About the same time I realized the seriousness of Lulu's issues, I learned Kathy's actual age. I had assumed she was sixty-five or so because she was beautiful, walked miles every day, did yoga, and sat easily on the floor.

I was off by a bit.

She was eighty. So I had just adopted out a high-energy border collie with serious separation anxiety to an eighty-year-old woman living alone.

Uh-oh.

Here's the thing. What looked like a very bad idea on paper was a perfect match in real life.

Kathy simply decided to stay home while Lulu adjusted. A hiatus was put on all exercise classes, luncheons, and errands. She kept going to her part-time gig at the church gift shop — because she

could bring Lulu, who became a big favorite with everybody there. Knowing exercise and social-ization should help, Kathy and Lulu walked miles together every day, in addition to enjoying an almost-daily playdate with neighbor dogs.

After a month, though, Lulu was still panicking horribly at being left alone. I watched with bated breath as Kathy dug in rather than give up. She brought in a team, namely a vet and a trainer. There was medication. There were hours and hours of training — two different six-week classes, plus practice — which eventually resulted in a "Canine Good Citizen" designation for Lulu, which is the national gold standard for behavior.

Afterward, I ran into their trainer, Mike, who exclaimed with a giant smile, "*They* are why I do what I do!" He said he had never been prouder of any other dog-and-handler team. Slowly but surely, the separation anxiety improved.

Here are some excerpts from the ongoing email exchange I have had with this lovely human, who has become more to me than just an adopter of one of my fosters.

DECEMBER 23 [DAYS AFTER ADOPTION]

I am going to a yoga class tomorrow, so Lulu will have another hour in the crate. I have turned it so she can see the TV. I haven't figured out her favorite channel yet...

DECEMBER 26

This is our anniversary (one week!) and things are going well. My love for her grows every day...

APRIL 3

Lulu is the light of my life...

APRIL 6

Miss "high energy" only had a two-mile walk yesterday, as I had a cough and bad cold, so this morning she jumped on the kitchen table. Message received...

SEPTEMBER 1

I'm glad you asked about Lulu, as most of the time, I talk about her nonstop — without requests! She makes me laugh every day, especially in the mornings when she curls up in bed right next to my face...

Just recently, Kathy made the decision to sell her big old house of forty years and move into an assisted-living facility. She wrote to me about the transition. Take a moment to sit with her words:

You must know that I couldn't have survived this incredible life-changing event without Lulu at my side. We look at each other with deep love, which I can't help but think extends beyond the two of us...

Kathy and Lulu visited the dog park on the premises of the new place. Right on the spot, the on-site trainer recruited them to be a therapy team, welcoming and cheering the residents. How about that: Lulu became a therapy dog after all.

MIRACLE MAC

The vet told me I'd better get prepared to lose this goldendoodle pup. Macaroni had pneumonia. We were trying everything, but Mac got thinner and more lethargic by the day. The one thing that seemed to bring him comfort was when his brother Yankee would gently cuddle up with him. I was so grateful for that.

At long last, amazingly, Mac turned the corner. By then my friend had fallen for him. Not only did she adopt him, but she convinced her next-door neighbor to take Yankee.

That first week, the two families put a gate in the fence between their two properties. It's just as heavenly as it sounds. Life is one long playdate with a best friend for those boys.

KID GOES TO COLLEGE AND FAMILY ORDERS TAKEOUT

It had been out there, looming, but finally there it was: Our firstborn was off to college.

If you're a parent, you read that and either thought, "Woo-hoo! One down!" or you kinda threw up a little bit in your mouth.

I'm in the second camp. I had been hoping that Grace would do us the favor that so many kids do senior year: become such a pain in the butt to live with that you practically toss them out of the car once you reach campus. That did not happen for us. True to her dang name, that kid became, if possible, even more of a delight to have around.

I hadn't meant to be a stay-at-home mom. I'd had a great job in magazine publishing, and I did freelance projects when the girls were babies. I figured I'd ramp up that work as they grew. Instead . . . I ramped down. Why? Because I got lucky, and all the factors that shape the experience of a stay-at-home parent fell my way. As Grace's departure approached, I mulled over the fact that I couldn't imagine any phase of life that could be more interesting, more rewarding, or more fun than the twenty-odd years with our girls under our roof. The inevitable parade of "lasts" marched by, and Grace's senior year became a time of continual lumps in the throat for me.

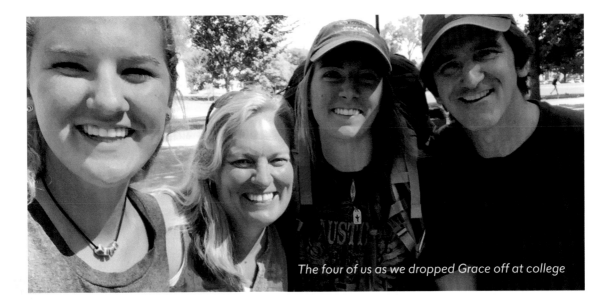

The four of us as we dropped Grace off at college

One stands out. Band was where Grace and her friends made their warm, quirky, funny, safe home in our giant high school. The biggest part of that experience was marching band, and that's where I'd done my lion's share of parent volunteering. One late October night, in a stadium parking lot, the Wolverine Marching Band was warming up for the last competition of the season, the championship. I watched, as I had dozens of times over the years, as the kids gathered in their "musical family" circles under the lights. As their gorgeous sound hung on that night air, something felt different, electric. I had the impression that I was suddenly, dramatically hearing their love for one another and their amazement in what they could do together.

I can still feel that moment. That final, culminating moment...

Then the call went out to line up. Percussion exploded into that cadence I had always loved, and the truth blasted through me with that sound: This was the last time. She was leaving. If my own realization wasn't enough to turn that lump in the throat into a full-scale sob, Grace whipped her head around right then. My girl — my cynical girl, who rolls her eyes when people say, "making memories" — searched for me with wide, teary, stunned eyes, and said, *"Mom."* It had hit her, too.

Over my sincere objections, the year stubbornly continued to unfold. The kids I'd known since elementary school laughed the night away on our trampoline, tore through our snacks, and draped across our floors in sleeping bags. The college admissions phase was followed by senioritis, and — gathering speed — prom, the last packed lunch, and graduation.

In September, our family loaded Grace's stuff into the giant van, climbed in with our three dogs, and drove ten-plus hours to New Hampshire. After one gorgeous, poignant, last-gasp week on vacation all together, our pack left one of its own on campus.

Other people get a puppy when this happens. That was obviously not going to do it for us.

We got nine puppies.

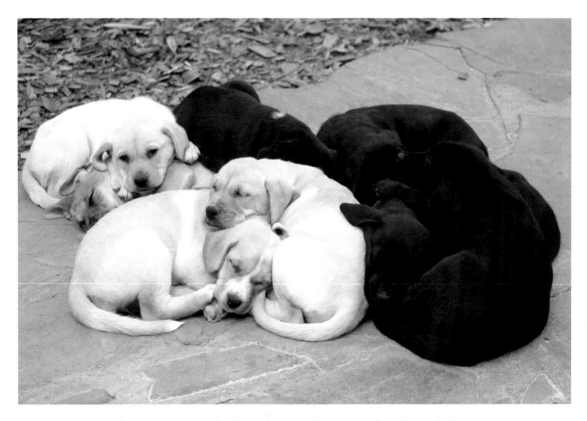

The arrival of nine foster puppies (eight shown here) made the nest feel decidedly less empty.

A week after we returned home, I got an email that a Lab/hound cross and her nine pups had been living under a porch in West Virginia. A few days later, they were filling up our house rather nicely. They were strikingly beautiful — five black, one red, and three yellow. Did I mention there were nine? I was immediately, thankfully, crazily busy.

We have an evolving list of puppy-name themes on hold for just this type of occasion. Our younger daughter, Claire — now no longer at the mercy of sibling negotiation — determined that this would be our Chinese Takeout Litter. We cracked ourselves up christening them as we bathed them in batches in the upstairs tub: The little blonds were dubbed Egg Roll, Moo Shu, and PuPuPlatter; the tawny red one was Dumpling; the five shiny black pups became Wonton, Kung Pao, Lo Mein, General Tso, and the chunky boy who loved to sit still, Beef-on-a-Stick.

Given that their puppyhood was likely deprived — under a porch and all — we got ready to super-socialize them. We began posting "visiting hours" on Facebook. Many afternoons and evenings, we had moms and kids "dropping by" from 3 to 6 PM, to the point that it was not unusual to have fifteen people hanging out in our yard. Because nine is really *a lot* of puppies, there were always enough fluffy bodies to go around.

Many dog experts say that well-adjusted puppies should meet a hundred different people by the time they're three months old. We easily hit that mark in two weeks.

The puppy happy hours gave me plenty of compelling Facebook photo fodder that revealed just how darling an addition to any family these pups would be. The result? Seven out of nine puppies were adopted to friends and friends of friends within a ten-minute radius.

We went on to have weekly playdates as the pups grew, and human friendships developed right alongside those puppies.

Once the house was empty again, my thoughts turned back to this litter's mom, who happened to share my daughter's name: Gracie. Because the pups were already eight weeks old upon arrival at our rescue center, the plan was to separate them from Gracie right then. When I got there, I meant to simply grab the crate of pups and go. I didn't plan on seeing the mama in the next crate over and making eye contact. Oy. I steeled myself, went up to her, told her what a good job she'd done, and promised I'd take good care of her babies. Then I shook it off — there's a lot of "shaking off" in rescue work, or else you just can't do it — and I focused on the puppies.

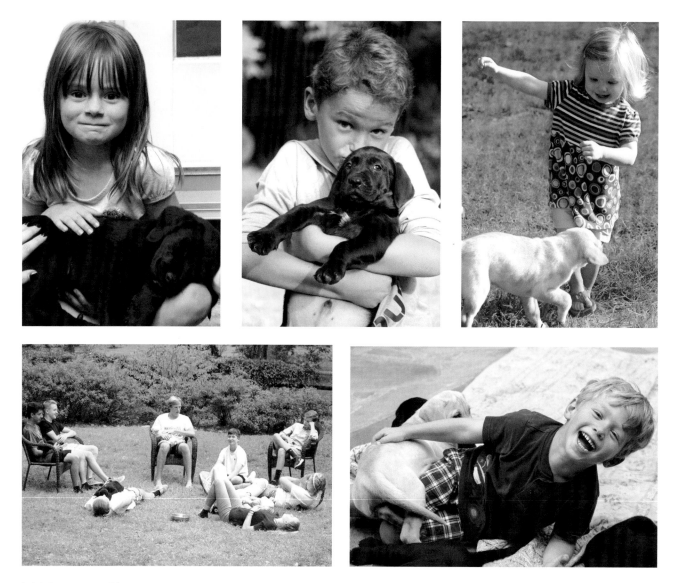

I think everyone I know came to visit our Chinese Takeout Litter. In the group shot (bottom left), Claire's friends are hanging out with a pup in each lap. And yes, that adorable girl with the "please?" expression (top left) did get a pup from this litter, as did the laughing boy (bottom right).

They kept Gracie at the adoption center, with the idea that she'd be on display for potential adopters while she awaited her spay. By the time she was ready for the surgery, all her pups had been adopted out and my house was empty. I offered to foster her during her recovery.

Gracie was delicious in every way, and our longtime good friends, who'd been able to resist so many of our fosters, fell hard for her. She now lives two minutes away, with true dog people who can't get over how much they love her. And yes, every now and then Gracie gets to see a whole bunch of her kids.

Throughout my daughter Grace's senior year, I had dreaded the following September when she'd be gone. Thanks to the Chinese Takeout Litter, it was a month surprisingly full of laughter, joy, and friends. That positive distraction — filled with mom-like nurturing — was the tonic I needed to get over the initial hump.

It occurs to me that starting to foster dogs a few years before Grace flew from the nest was a stroke of (unintentional) genius. I got three years of practice letting go of little beings I adored nurturing. Three years of practice taking deep breaths and trusting that they were ready. Three years of having faith that soon I'd see evidence that all was well.

Mama Gracie

Who knows if it's because of the fostering, but I swear the very minute we left Grace on that campus, I knew she was going to be fine. Soon enough, we were getting the evidence we needed: texts, a Skype or two, calls, Instagram posts. She was happy. She was herself. She was exactly where she was supposed to be. It was so very oddly just like getting those first happy photos from an adopter, showing a pup utterly settled in a new life.

Which is not to say we didn't, and don't, miss Grace and the days when we all slept under the same roof every night. What I hadn't realized, though, is how much fun it would be to delight from afar in her new adventures, her new friends, her new thoughts. I hadn't known that, when she would eventually come home, it would feel not only normal, but somehow like normal on steroids, with a giant dose of appreciating every moment thrown in.

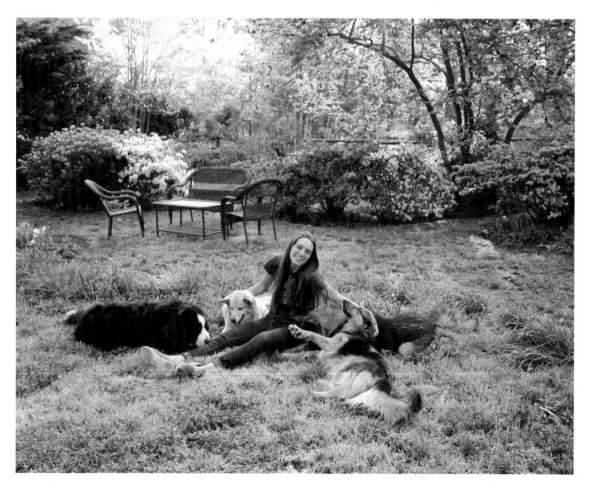

Grace surrounded by our pack on one of her stretches back home

ANOTHER UGLY MUTT

"Mutt" = homely, right? Here's foster mutt Wonton, who respectfully suggests that mixed-breed dogs can be some of the most beautiful ones around.

A REUNION OF MOM & PUPS

Mama Gracie had been separated from her pups for a few weeks at this point. We weren't sure if they'd remember

Chapter 5

THE PUPPY WHO WAS LOST...AND THEN FOUND

Your first foster litter is a little bit like your first love: It's intense, and you remember every detail. That's why I can tell you, a full five years later, that Helga was the one who made us laugh. She was the comic relief of that precious initial litter of seven. Giant Helga — by far the biggest pup — would suddenly catapult herself across the entire gang from time to time, for reasons impossible to discern. She would vocalize with hilarious grunts and squeals as she ran over for a snuggle.

For years, those memories of that darling puppy haunted me because I did not know what happened to her.

When you foster for our local public shelter, you're not involved in the adoptions. You simply turn the puppies back over to the shelter when they're eight weeks old. While I know our shelter has a caring staff, it's hard to see the pups go from a warm, lap-filled home to a concrete kennel surrounded by rows of barking dogs. What's more, instead of the typical private rescue–group approach — usually a weeklong process where adoption counselors review applications in search of the best match — an adoption can happen on the spot.

The litter reunion — minus Helga

In the case of the litter we were fostering, the shelter opened the doors on a Saturday morning and our pups were all gone by noon. In my mind, the odds were high that these pups could land in homes where the adopters may have made an impulsive, emotional decision, and they were in no way truly prepared for the demands of puppyhood.

Rather than rolling her eyes at the way-too-involved foster lady, the kind, brand-new shelter director understood my dismay with the system and came up with an idea. The rules kept her from sharing adopter information with me, but if she invited families to a six-month birthday party, then I could connect with them myself.

Those were four long months for me.

Finally the day came. The dogs bounced in, one after the other, and soon the shelter was filled with a joyous pack of my now-huge, very happy puppies and the owners who loved them. It was fantastic.

Except…there was no Helga.

No sweet, funny, goofy, cuddly Helga.

I tried to tell myself that wasn't a bad sign.

Alas, it was.

About three years later, I got a call from the same shelter director. Helga was back. She'd been turned in by her owners. She had serious medical and behavioral issues, she wouldn't let anyone touch her neck, and she needed Prozac to get through the day.

It was my worst nightmare. In the intervening years, I'd gained some distance and had

convinced myself to stop worrying. But here it was, roaring back, just as I'd feared. I'll never know what obstacles the owners may have been facing, but it was clear that Helga was in bad shape and may have had a rough time of it all along.

We visited her. The shelter's a tough spot for a dog who's used to a home, and this was no exception. She was freaked out and growly. It was impossible to see our hilarious, loving little Helga inside this unhappy, intimidating big dog. The vets had determined she needed a five-thousand-dollar double hip replacement. Even if the shelter could fund it, it would mean months of recovery that could only happen in a foster home. I reflected on her demeanor at the shelter and the fact that my active, dog-filled home clearly wasn't right for convalescence. I felt sick. If even I felt the need to say no to this foster dog, who in the world would say yes?

I made myself walk away. Then I emailed the families of the rest of the litter to warn them about the hip dysplasia, which is often genetic.

The next thing I knew, I was — impossibly! — looking at a picture of Helga on the couch with her brother Spex. Our old Speckle Boy, now Spex, had been adopted by my friend Linda, who was at the shelter when it opened that June morning so she could snag the puppy she'd come to love at my house. Turns out Linda couldn't stand to see her much-adored boy's sister in such a horrible situation. After my email, she had reached out to the shelter and offered to foster.

In turn, the shelter, which had already done so much for Helga and her litter, went one giant step further: They decided to tap their special medical fund, generously sponsored by their donors, to cover the cost of Helga's two hip surgeries.

Whoosh! Just like that, a tiny missing piece of my heart was put back in place. Our puppy was finally in good hands.

Linda and her three dogs gave Helga the gift of a safe landing spot. This pack retaught Helga how to play, kept her company, and eased her fears. She transformed before my very eyes and started to smile. Even a week into her time at Linda's house, she was absolutely a different dog. Three months into that stay, it was clear her surgeries had been successful. She was running. She was off Prozac. She was…adoptable. Linda started getting emails from the shelter about supplying photos and doing a write-up to generate interest.

Now the gulp. Here we go again. Where would this dear girl land this time? She'd made

Smiling Helga, at home with Linda

so much progress and had fully become herself again. To think another unproven owner could step in…

Ha.

That wasn't going to happen.

Helga is now a permanent part of Linda's pack. The adoption was a surprise to nobody but Linda.

Sometimes people don't — or can't — do right by their dog. Then other people step in and go beyond right and into beautiful. When I think of Helga's story, I do my very best to hold on to the second part and simply let go of the first. There are lots of opportunities to do that in this dog-rescue world. The trick is keeping your eyes on the right half of the story.

THE MANNY

I doubt there's a dog out there with a more impressive childcare résumé than Eli. When he looked after Daisy's kids, they were clearly starstruck by his magnificence.

"WAIT...WHAT DOES 'ADOPTED' MEAN?"

Xylophone, Glockenspiel, Marimba, Chime, Timpani, and Bongo had been with us a month. The pups had just turned eight weeks old, so this was adoption day. They listened very closely as I explained that they were about to join some very nice families.

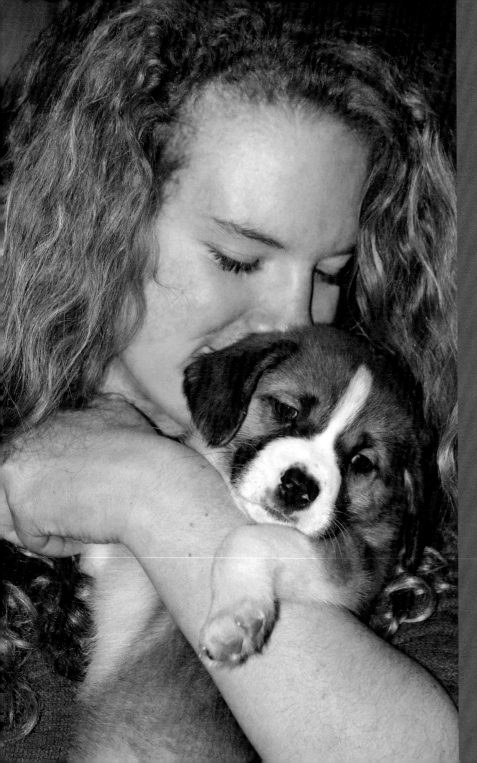

A FLUFFY ANTI-ANXIETY PILL

Moms will sometimes tell me their kid is having a rough day and ask to visit. It's hard to remember what you were so worried about once you get to do what Claire's doing here with Meadow's puppy Lake.

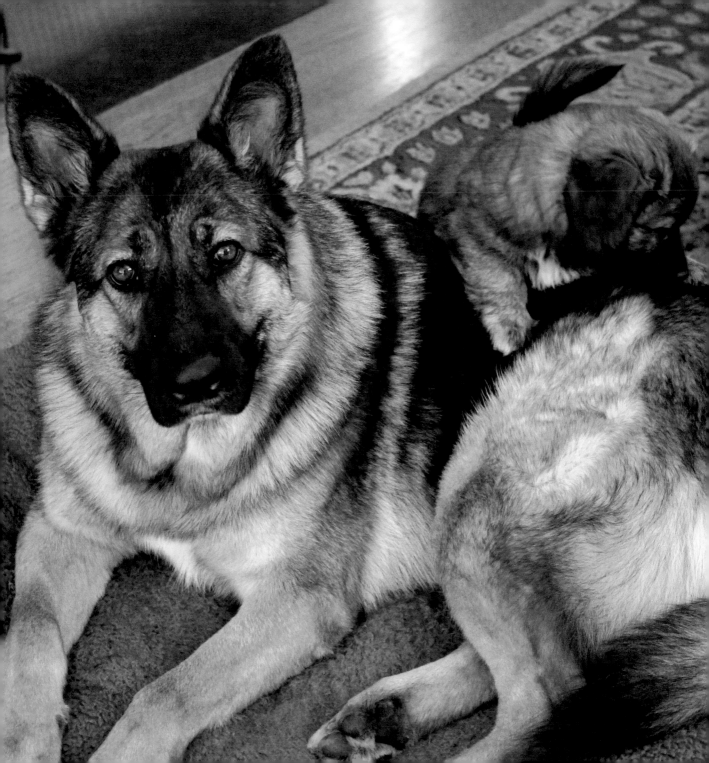

Chapter 6

FINDING OUR MOJO

It was no more than a ten-minute exchange. I had never met the woman before, and I haven't seen her since. Still, her words are seared in my memory. They had an omniscient ring and sent a chill right up my spine.

"You've never lost a litter? Oh, my dear, it's only a matter of time."

It's scary how many things can be life-threatening to puppies. The most famous — the dreaded, deadly parvovirus — is highly contagious and moves with alarming speed, but there is frankly a wide range of parasites and respiratory issues that can devastate fragile young litters.

I tried not to think about it as we took in another litter, then another. In the back of my mind, there it was: "Puppies die," she'd said. "One after the other. Sometimes whole litters." She was an experienced foster. She knew.

When you foster, sad dogs on the brink of euthanasia fill your screens every week. This is not an exaggeration. As I write this, seven hundred thousand shelter dogs — most of whom are healthy and adoptable — are put to sleep every year in this country. One or two each minute. If you foster, you cannot take them all. It has to come down to the ones you simply can't refuse.

One May, amid the parade of needy faces, there was a shot that reached straight into my gut. Gazing directly at me was what looked like a wolf — a wolf who should have been majestic, but instead was utterly dejected. She was surrounded by concrete, and her babies were strewn in front of her. I couldn't tell if her look was accusing or hopeful.

Either way, my answer was yes.

The photo I couldn't refuse

The story came later, in dribs and drabs. The mama dog and her eight less-than-two-week-old pups had been left overnight in what the North Carolina shelter calls their "drop box" — the outdoor pen used by people who want to give up their animals but don't want to face anyone in the process. The sad calculation is that the drop box results in fewer dogs abandoned in the woods or the river.

The litter spent a few days in the shelter, where mama earned a reputation as a growler. "Hmm…," I thought when I heard that, pondering my primary responsibility to our family and our own dogs. Homeward Trails had contacts in the area who visited, assessed mama's temperament, and decided this was indeed a litter we should "pull" into the rescue, which is always a relief to a rural shelter with fewer potential adopters.

Their ride up to Virginia came in the form of a four-seater plane flown by a spry seventy-year-old pilot named Mary, who is often up in the air with dogs. As a volunteer with Pilots N Paws, she had been flying rescue dogs into better lives for the past ten years.

As Tom and I waited for Mary out at the airfield, we considered the wisdom of bringing into our home a "growly" wolf-dog — probably unsocialized and possibly abused — with eight pups to protect.

As usual in life, we were worrying about the wrong thing.

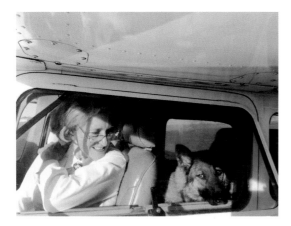

Arriving in the little plane with Mary, the volunteer pilot

The first clue was that there were only six pups with their mama on that plane.

There was no time to digest what that meant. We pulled the family out of the plane, bundled them into the van, and then snuggled them into the basement den. Since mama looked so much like a wolf, we named them after national parks: Mama Denali, then Smokey, Kenai, Acadia, Jasper, Arches (Archie), and Sequoia.

Then we began to marvel. We became more smitten by the hour. Denali was absolutely stunning. We began calling her our foster wolf. Far from the defensive creature apparently on display at the shelter, she was utterly cooperative and trusting.

Of course, the puppies were darling. Three were a tawny black-and-tan, and three were mostly black — including Smokey, the one with the white blaze that everybody had noticed in the sad "before" shot from the grim shelter.

By ten in the morning, Smokey was standing out for another reason. She was crying. I was calm for a while, trying the things I knew to try. I was keeping her warm and encouraging her to nurse. I began texting for advice. By noon, I was alarmed and phoning for help, stunned by the speed of her decline. By one o'clock, I knew she was dying. I rushed her to the vet.

The look on my vet's face told me everything I needed to know. Smokey was off-the-charts hypoglycemic and anemic. The cause was unclear — infection? hookworms? — but she was not going to make it. There was more. The vet said, "I think you need to prepare yourself that you might lose this entire litter."

Boom. There it was. My time had come.

I suppose it sounds extreme to admit I was sobbing on the way home in that empty car. After all, I'd known that puppy for less than twenty-four hours.

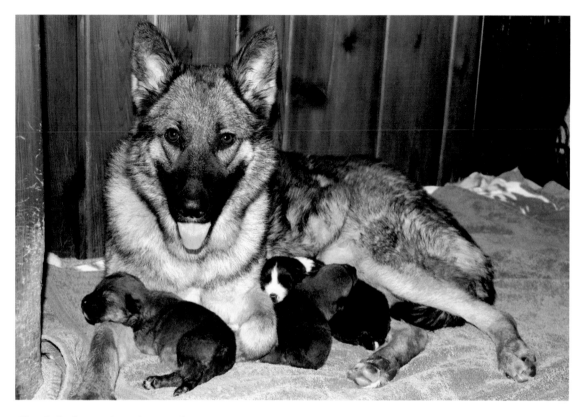

Clearly feeling safe and relaxed, Denali and her puppies just hours after arrival

The thing is, you love them fully, absolutely, the moment they land in your house. That very first second, you are all in. At this point we'd been fostering for four years, and the fact that we were so experienced made it worse: I felt acutely every single thing we had just lost. Smokey would not have those sweet weeks cuddling in a warm pile with her littermates. She would not stumble into the idea of play. She would not hesitantly step onto the grass, and half an hour later be romping drunkenly around the yard. She would not start to make eye contact with people and ultimately steal the heart of her human. She would not lay snuggled up with her boy during story time.

She would have none of it.

In those next hours with the litter, my confidence left me. I wasn't sure how I could handle what might be coming next.

I regretted my blithe choice to post on Facebook about this group before their arrival. Now I felt the need to explain what had happened to "that cute little one with the white blaze." So, hidden way down in a post where only a careful observer would come across it, I noted that Smokey had died.

Turns out a lot of people read carefully when it comes to darling puppies.

I cannot tell you how many notes I received within hours. People whom I had assumed

Little Smokey, getting warmth from her mama's fur

had "hidden" my too-frequent dog posts — who'd never once commented — wrote me private messages telling me how much joy the stories of our fostering had brought them and how very sorry they were about Smokey. My email was suddenly jam-packed with photos of foster alums, with sweet notes about how beloved they were and how much they had added to their family's lives. Cards were stuffed in my mailbox, soup and flowers left on my porch.

I was floored, and moved.

Now newly, wonderfully aware of a strong scaffolding of support in play, I felt able to put one foot in front of the other — to take a deep breath, brace myself, and dive in to help the five remaining pups if I could, and to love them if I couldn't.

Those next weeks were challenging, both emotionally and logistically, and the learning curve was high. We made trips to the vet and consulted with experienced rescuers. The deworming medicine had live, swarming results (think spaghetti that moves), which lent credence to the parasite theory. Antibiotics seemed to perk up the pups, indicating some kind of infection might be at work, too. Denali was a reluctant nurser (was nature telling her they wouldn't make it?), but her pups desperately needed that nutrition. Regardless of their medical state, missing a day's feedings could kill them through dehydration alone. I struggled with bottle-feeding pups who were lethargic and uninterested. I dabbed a squeeze of a glucose supplement on their tongues several times a day hoping to perk them up enough to eat.

Kenai was the most immediate worry. She was the runt of a very sick litter, and one of her still-closed eyes was bulging ominously. It took me an hour to get the crust off with a warm washcloth, and when I finally broke through, a crazy amount of pus came out. I couldn't imagine that an eye could have formed normally under there, but frankly I didn't think she'd live long enough for us to find out.

As I had dreaded, she started to fade the day after Smokey died. Without much hope, I brought her and Acadia, who was also weak, to the vet. As I signed in, I placed my sad little box-of-two-ill-pups on the counter. In a stunning turn of events, little Kenai popped up. The tiny pup who'd been almost comatose climbed to the edge of the box, pulled herself up to standing, and seemed to peer around — with her infected, sealed-shut eyes. The sounds and smells of this new environment were too much for her to resist. I was blown away by her will.

It was a short-lived feeling of exhilaration. The vet took one look at the puppies' gums — truly

white, not even pink, they were so lacking in red blood cells — and gave me the same grim warning I'd come to expect: "You may lose them all."

I headed home and honestly waited for Kenai to die even as I kept applying a goopy antibiotic to that scary-looking eye.

Instead, it was Acadia who began to cry that night, exactly as Smokey had. I knew what was coming. We snuggled her and kept her warm. We told her how sweet she was. At first she cried and cried, and then around midnight, she stopped. I kept checking, thinking she had passed away, but she was still breathing.

At 3 AM, I saw the strongest pups, Archie and Sequoia, get up and go over to that dear puppy. Archie put his paw over her, and Sequoia rested her chin on Acadia's head. They stayed that way for maybe five minutes. Sure enough, after that she was gone.

Those words seem absurdly small when I write them here.

What happened in that room was not small. It was everything. It was all the love in the universe showing up right where it was needed. I wept. I still weep. I'll hold that moment forever. Those tiny, not-even-four-week-old souls, bringing comfort and respect.

As the next few days ticked by, I became cautiously optimistic.

Spirited little Kenai

Kenai was hanging in there, and Archie, Sequoia, and Jasper actually began to play. They were happy and growing. It started to feel normal and fun in the puppy den. We laughed at their antics. Mama Denali started to full-on wrestle with them, and we cracked up at how she was really more of a cool, roughhousing dad than a sweet, nurturing mom.

Just as I began to exhale, though, beautiful Jasper took a turn. A day later, Tom and I were saying our goodbyes as the vet put him to sleep.

It was happening. "Puppies die. One after the other. Sometimes whole litters."

Not this time, though.

Archie, Sequoia, and Kenai reached five weeks, and then six. Their gums were pinking up, and they were eating like champs. Archie and Sequoia — always the strongest — began ramping up the fun. They had become fluffy, darling little bears tumbling around and exploring just as they should.

By weeks seven and eight, tiny Kenai caught up. Every day that little fighter got stronger, more active, more alert. To my utter amazement, those eyes cleared and she could obviously

Mama Denali with Archie, Sequoia, and Kenai, finally out of the woods

see. The first time I witnessed her pounce on Sequoia I was overcome. I was the crazy lady telling anyone who'd listen that my puppy had started to play.

Finally, after six weeks of intensive care, we had three healthy puppies and a very happy mama dog.

I long ago stopped stressing much about who's going to adopt our fosters. Inevitably, magically, the right people seem to show up at our door.

These three dear pups ended up exactly where they were supposed to be: Archie with a retired couple who now have new joy after the passing of their old shepherd; Sequoia with a sweet military family that was finally in one place long enough to get their long-awaited dog; and Kenai to a family just weeks before the dad deployed overseas. All are now cheering their people, all are bringing great joy. Kenai's dad always wants to Skype from Yemen: "Put the puppy on!"

The giant bonus: All live within ten minutes of me, and one is right up the street. I get to watch them grow up.

Then there's that last placement: Mama Denali.

Her face in that sad photo drew me to this litter. She'd been unceremoniously dumped by her owner, and she came to us sick with hookworm, covered in ticks, thin, and bewildered. Her babies were dying. She had every right to be frightened and acting out. Instead, she just looked at me with those giant brown eyes, that furrowed brow, and asked what was next. She chose to sleep with me on the couch as I watched over the litter, and I caught my breath when she put her paw in my hand that first night. The next day, she gave me a play bow, and we wrestled.

I can't lie. It did, right then, strike me that this was obviously a Callahan dog. Still, we were not in any way looking for a fourth (!) big dog. Plus, the odds were that this strong personality with pups to defend would not meld into our pack.

Sure enough, when she first saw our dogs, she reacted fiercely, with intense barking and lunging. In response, our dogs...swished their tails. She was barking her head off and threatening them, and they just...said hi. It was like they had talked it over and decided, *Look, the new girl's going to be especially freaked out, so we have to go out of our way to be chill.*

Within a day or two, absolutely everyone was smitten with one another. The boys were head over heels, and our earlier "foster fail" Nala was playing in a way she never had before. Like she'd been waiting for a sister.

Uh-oh. She really was looking like a Callahan dog.

We thought about the other obstacles. She'd probably be terrible with kids, since she'd likely never been around them — then a potential adopter brought her five-year-old boy, and Denali tenderly placed herself so that he wouldn't fall off the step. We figured she'd threaten our fostering, since she might be tricky around other dogs — then friends came by with their dogs, and she proved herself the most fun playmate possible.

Before this litter, we had given away ninety fosters and managed to keep only one.

Now we've kept two.

Out of all this death, our pack found new life. Because of this mama dog who's been through so much, there is constant playing again. Every day, Tom and I are transported back to the first years of our marriage when we had four large dogs. It was a tight pack, it had just the right amount of chaos, and it was wonderful. That's why, when we realized we had to come up with a new name — since Denali and Nala were too similar to be in the same household — we settled on Mojo. This dog has indeed been a "magic charm" for us. We have our original mojo back.

We took in three eight-week-old foster pups about two months later. It was as if Mojo had been waiting for them. She was never more than a foot away. She inspected them, entertained them, and disciplined them. She'd sometimes just gaze as they played, contentedly overseeing, thrilled to have this job. Other times she'd sweetly wrestle for half an hour, always with an impossibly gentle mouth. One evening I saw her grab an empty paper towel roll from the kitchen and walk it over to the pups, dangle it enticingly in front of them, drop it, and lay down to watch.

Witnessing Mojo playing with those three, I'd take a breath as thoughts of the lost pups Smokey, Acadia, and Jasper washed over me. It's not the first time I've felt our fosters begin to blur into one beautiful tapestry of sweet, funny, tender joy, but it's the most profound.

In *The Prophet*, Khalil Gibran writes:

When you are joyous, look deep into your heart, and you shall find
 it is only that which has given you sorrow that is giving you joy.
When you are sorrowful, look again in your heart, and you shall see
 that in truth you are weeping for that which has been your delight.

Before Mojo's litter, I did not want that woman to be right. I did not want to have a litter where "puppies die, one after the other." Of course, I still wish it had not happened.

And yet.

Over the coming years, as we watch Mojo mother countless foster puppies, the joy will be all the deeper because of that new band of sorrow woven into this rich tapestry.

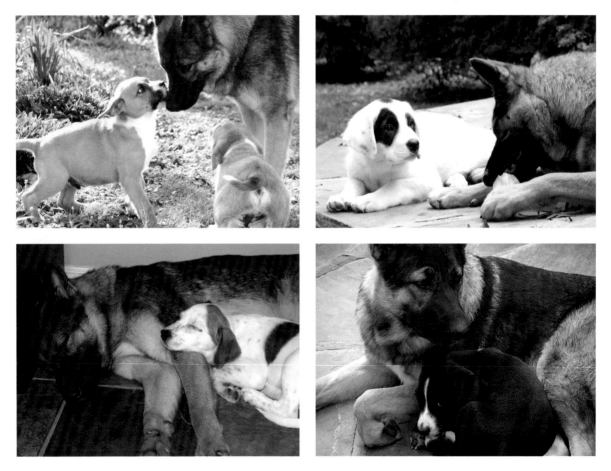

Mojo with just a few of the pups she has mentored; clockwise from top left: Johnny and Joey, Templeton, Scout, and Sally

INTERSPECIES FUN

Friendly interspecies mingling never fails to delight. Our dog-savvy cats stand their ground instead of running, which leads to memorable moments like this: intrigued puppy Sunday, quietly investigating Leo.

EVALUATING THE SITUATION

For the first time ever, pups from the Spice Litter were daunted by something. Pepper, Poppy, Saffron, and Paprika took a moment to evaluate this snow-and-ice thing. Don't worry. They concluded it was fabulous.

Chapter 7

A BORN LEADER IN ACTION

When a litter of wriggling puppies suddenly descends on your yard, it often takes a while to tell them apart, much less to get a firm handle on personalities. With the "Chinese Takeout" gang, though, one guy immediately stood out. He was the obvious leader, but not because he was pushy or dominant. He simply struck us as … responsible. As the days went on, we saw he was remarkably observant, mature, and even-tempered. While we had fun giving the others names like Egg Roll and Wonton, this guy earned the respectful moniker General Tso.

September was an ideal time to have these nine big, active puppies because we could all be outside most of the day. Every now and then I'd dash inside to put in a load of laundry or to pay a few bills, but I was always looking out the window and listening for unusual cries. Sometimes you don't know you have a hazard in your yard until somebody discovers it for you.

One day the pups were out, and I was spending a few minutes working at my desk. Suddenly, the General came zooming around a corner. He jumped up on the glass door between us, made serious eye contact, and cried. Desperately. Uncharacteristically. I opened the door, but he wouldn't come in. Instead, he ran the other way. I followed and became aware that I was — oddly — seeing very few puppies.

We rounded the corner and it all became clear. A handful of puppies were looking down into the basement window well, where the always-adventurous Moo Shu and Dumpling were trapped and crying. I scooped them out and thanked the General for his service, pondering this special dog.

Among those interested in this litter was a local woman, Megan, with four little boys under age eight. She thought she wanted a puppy. Four. Little. Boys. Under eight. Of course, my going-in position was "HA. No, you don't." I set out on my usual path of dissuading a delusional potential adopter.

The initial conversation, however, took place in my yard, which was full of my puppies and her boys. I watched. Holy mackerel. This woman had high expectations for behavior. She followed through. She was mellow about things like getting knocked down. She said, "Hey, your own fault," when a kid's dangled snack was taken by a pup. Even more, those boys were actually interested in the dogs and treated them like live beings instead of toys put on this earth for their amusement. The cherry on top: Their mama was joyous in the chaos, rather than rattled.

I put my dissuasion speech on hold. Megan and her four boys became regulars at our puppy-visiting hours that month, and by the end I was a total convert. They'd be an amazing pack for a puppy, and I knew exactly which one was beautifully suited to the task of lovingly overseeing this rambunctious team of boys.

Of course, they chose the General.

A little side note to this story: While we were fostering this litter, over and over I found myself thinking of the General as "Captain." So weird. I never told anyone because it was a little embarrassing to reveal what seemed like a deteriorating brain!

The General calmly engaging with a visiting baby as his littermates romped nearby

Then Megan adopted the General, and a few days later called to say, "We figured out the perfect name! We're calling him Captain."

My interpretation: The glitch wasn't middle-age decline after all, but just a tiny glimpse into a fated future.

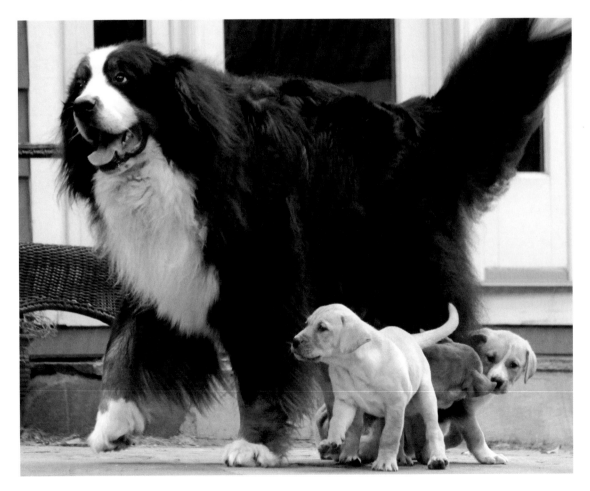

With his benevolent leadership, General Tso was channeling the master, Eli, shown here with Egg Roll, Dumpling, and PuPuPlatter.

BIG FUN.
BIG MESS.

Note to self: When you're about to say yes, think about size, number, and season. Meet the Spice Litter. That's Poppy, Chili, Pepper, Curry, Paprika, Saffron, Sage, and Cinnamon. MIA is Nutmeg, as usual! Future eighty-pounders. Nine of them. And it was a cold, snowy January. That is an insane amount of indoor chaos, destruction, and cleanup. The basement will never be the same, but it sure was fun.

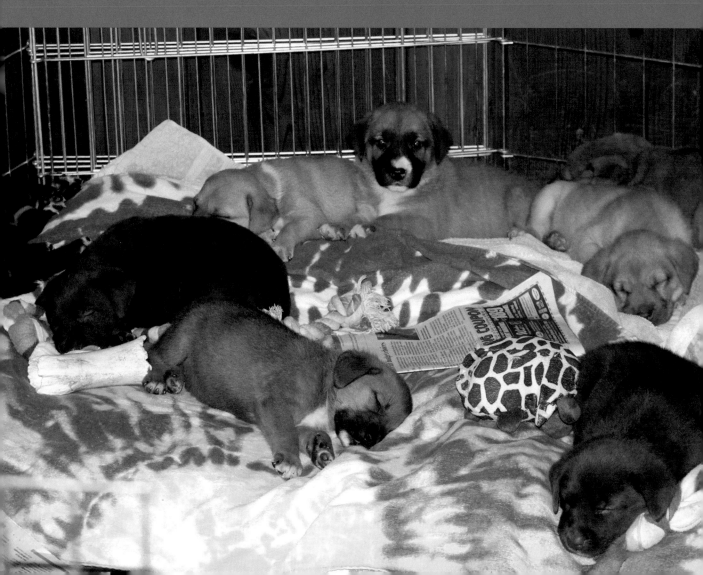

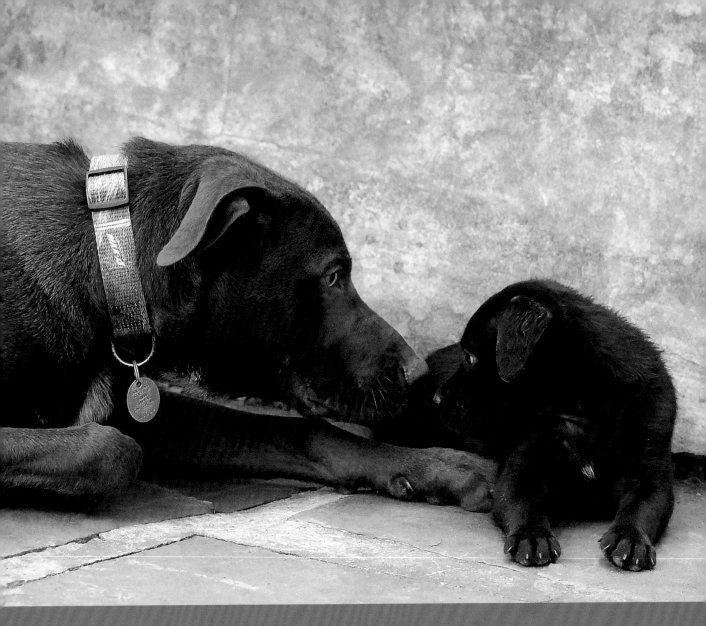

"YOU'LL BE FINE."

Sometimes our alums happen to drop by while we have new foster pups. I like to think they end up giving some reassuring advice. This is all-grown-up-and-beloved Chili from the Spice Litter connecting with Aladdin.

THE SURPRISE OF A NUCLEAR FAMILY IN AN ABANDONED SHACK

We'll never know if Meadow and Dex once lived a cared-for life with humans in that abandoned old house in West Virginia. All we know for sure is that they were sheltering there, doing the best they could to get through a winter with their five puppies.

A report of a stray dog sighting brought the rescue folks to that dilapidated shack in early March. Finding puppies in the picture was no surprise, but it was unusual to find a daddy dog who'd stuck around. Judging by the age of the pups, this little family had been braving it on their own for at least a month, foraging for food and trying to stay warm enough during that brutal winter. Both Meadow and Dex were terribly thin, and their coats (an indicator of long-term health) told a sad story. Not so the pups! The pups looked like they could have come fresh from a breeder. They were plump, fluffy, and content. Meadow and Dex had done well.

As the rescuers focused on the tricky task of collecting an untrusting mom who was guarding her pups, they gave a passing thought to leashing up daddy Dex first. But they saw his quick hopeful wag and wagered he wasn't going anywhere.

That turned out to be a fateful decision. By the time Meadow and pups were safely crated, Dex had vanished. After a while, the team had no choice but to head back without him.

Meadow was very quiet the first week or two at the "puppy room" at the rescue head-quarters. Once she set foot in our yard, though, we saw a very different, completely engaged Meadow, a hint that she'd been a bit shut down earlier. People who'd gotten to know her at the puppy room were stunned to see her adorable play bows to us and her frisky antics with her own pups and our big dogs. Turns out she just needed some sky. She was clearly more comfortable outside, lending credence to the idea that perhaps she and Dex really had been on their

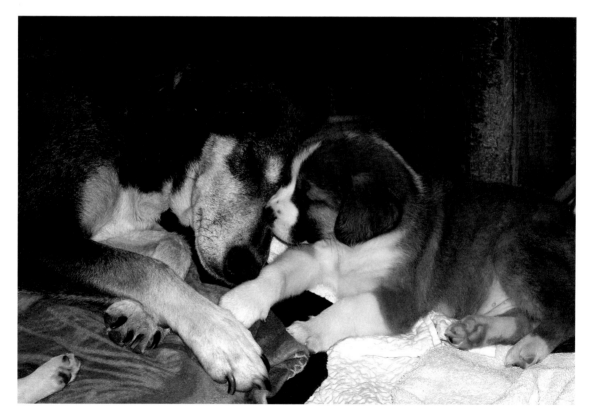

Mama Meadow snuggling with Lake (above), *and with Dogwood, Flora, and Cedar* (facing page)

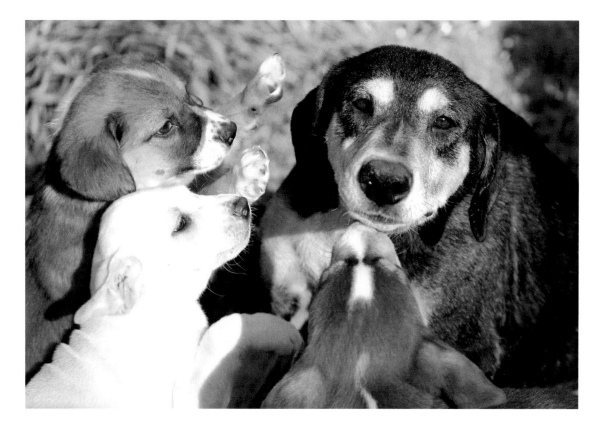

own for quite some time. As often happens with good nutrition and a decrease in stress, her coat improved — that straw turned softer, and bald spots grew in. Things were looking up for Meadow.

As for Dogwood, Lake, Brooks, Flora, and Cedar, these guys were perfect little paint-by-number types come to life. Applications were streaming in. We had an absolute ball with them, and they were happily homed within weeks.

Four out of five of them, that is.

Little Cedar, with his beautiful coloring and fantastic eye contact, was arguably the most photogenic, and he had loads of potential adopters asking after him. Sadly, right from the get-go

Brooks and Lake (top); *Dogwood* (bottom)

he had been a worry. He just wasn't moving right. Once the pups were bounding around, it was impossible to ignore: There was something very odd about his gait. The vets were concerned, and a spinal or neurological issue was a possibility. The worst part? It was a wait-and-see situation. It might turn out to be something minimal, and it was also possible that this pup wouldn't make it to his first birthday.

Somebody forgot to tell Cedar about his tragic circumstances. He was the happiest, goofiest little dude. Furthermore, he now had his mommy all to himself. The morning the last brother was adopted, Meadow stopped lounging on the couch (where pups couldn't reach her) and moved to her permanent station: attached to Cedar.

As I wrestled with Cedar's situation, I got the call about Dex. I've learned to block thoughts about dogs I can't help, so for that month I had put him out of my mind. I did not allow myself to think about Dex, who was now alone. I did not ponder whether he went back to the house, now even colder without Meadow and the pups to curl up with. I didn't wonder if maybe Meadow had been the best finder of food. I didn't speculate about how Dex felt to watch his family put into a cage and, well, kidnapped.

When the rescue called saying they had him, that was my cue. Suddenly, all the questions

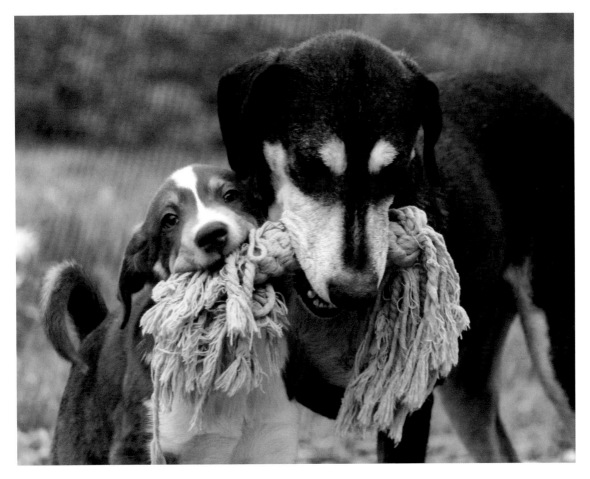

Last-pup-left Cedar and his mama, Meadow, formed an incredible bond.

and worries came flooding in. The rescue folks had gone back — and back, and back, and back. Finally they were able to trap him, and there was sad news on both the physical and emotional front. While the thin body and the gooey skin infection were disturbing, the description of Dex as "totally shut down" was what killed me. The experienced adoption center folks — who've frankly seen it all — were so concerned about his mental state that they were reaching out to me, hoping that a visit with Meadow might help.

The afternoon visit turned into a three-month stay. Of course. Those first hours were not a dramatic, YouTube-worthy Meadow-and-Dex reunion. The dominating factor that afternoon was Dex's fear. He was clearly traumatized by all this crating-and-strangers business, and instead of focusing on Meadow, he found a relative comfort zone on the edges of our property, taking refuge in the bushes and observing. We gave him his space and waited.

Within days, though, Dex, Meadow, and Cedar became an adorable mini-pack-within-a-pack. While they enjoyed all the other dogs, they were continually touching, playing, and seeking one another out. They moved as a unit, with both parents seeming to delight in and indulge Cedar. Meadow and Dex had a true friendship, and it no longer surprised me that a dad had stuck around after those babies were born.

While Dex got happier and happier with his little family (and played more with our dogs, too), his progress in feeling relaxed around humans was excruciatingly slow. He was so terrified it wasn't until week three that I got to pet him and until week four that he enjoyed it.

Dex, Meadow, and their boy Cedar formed a little pack-within-a-pack.

Once I realized the depth of Dex's skittishness around people, the issue of his placement became much stickier. This is a terribly difficult kind of dog to own. Progress on skittishness typically proceeds at a glacial pace. The vast majority of adopters would find a dog like Dex unrewarding and frustrating. In addition, he'd be a huge flight risk. If a skittish dog escapes out of a door that's left ajar, you won't ever see them again. Living that way is hard.

It became clear that, in addition to potentially unadoptable Cedar, we now had potentially unadoptable Dex. Plus the sadness of the looming, inevitable breaking up of this little family. Sigh.

Enter my friends.

Marie and Allison had two teenagers, and the whole family was still hurting over the death of their old dog. They were ready for the joy of a puppy. They came to visit over spring break, and they fell for Cedar even though they knew he might have a shortened life. After they spent some time thinking it over, their daughter's gorgeous response was: "Isn't it even more important that he has a loving home for whatever time he has?" So, Cedar it was.

However, this family had seen the pup's incredible bond with his mom. They were drawn to her, too, and felt it would be easier on both dogs to stay together. I smiled as I drove Meadow and her beloved boy Cedar up to Boston to live with my dear friends.

And guess what? Today, years later, Cedar still has a goofy gait, and the specialist vets are still unsure what exactly is up with him. But he is loved, and he and Meadow are hilariously, adorably inseparable.

It was hard to come home to Dex. Twice now we had stolen his family out from under him. He was okay, though, happy enough with my other dogs and making incremental progress. Still, I kept thinking nobody would be right for this achingly sweet boy who needed his heart unlocked.

Then Tom said, "What about Jill?"

Here's why that's weird: Tom barely knew this local mom. Why in the world it would occur to him that she'd be a perfect adopter is unfathomable to us both. The minute he said it, though, I knew he'd found our answer. Jill is a through-and-through animal person who had been involved with rescue work before, and she had successfully worked through serious issues with her own dog.

We texted Jill. She said yes in about a nanosecond. She and her kids, rather than being upset that their dog would only feel safe on his bed, cheered every single advance. They delighted in every eye met, in even the tiniest of wags. For anybody else, the progress would have been slow, excruciating, and unrewarding. For them, each inch was reason for glee.

Here he is, years later, with his so-very-beloved Jill, all the way out of his shell.

Thanks to Dex's owner, Jill, this painfully shy daddy dog is now one of the happiest dogs I know.

THE BROWN ONE

We took in three siblings: this pup named Brownie, a yellow one named Cheesecake, and a black one named Coffee Cake. Pretty much every day, Tom would see this dog and ask, quite sincerely, "What's this one's name again?"

EYE CONTACT AND TRUST

With each dog, the photos get better and better the longer they're here. It's all about trust. At first these little guys don't even know me, much less love me. But give it a week, and suddenly there is amazing eye contact. While I like beautiful photos, what I love best about this shot of foster Steffie is what it says about how she's feeling.

"NOW TELL ME THE TRUTH . . . DID YOU STEAL THAT BONE?"

Aunt Nala is no pushover. Our wee fosters — like Thursday here — quickly learn to treat her with respect, but that does not at all interfere with their joy in obsessively toddling after her.

Chapter 9

BRAVERY AND BROTHERHOOD

If you had caught sight of Timothy, Templeton, and Thatcher at the three-month mark, you'd have seen three hilariously oversize, crazily handsome puppies. They crashed around. They made a huge mess. With their growing-too-fast bodies and their big wrinkly faces, they looked drunk most of the time. Eventually, they always ended up in a big pile, sleeping it off. Frat guys. Sweet Great Pyrenees frat guys.

But there was more to those boys. There was a gentleness and a striking level of empathy. How do I know? Because, for a while, those boys had a brave little brother facing an uphill battle.

Hardship swirled all around this litter, which came to us from Tennessee. Back-to-back hurricane disasters meant Houston and Florida shelters had to empty out, and fast, to make room for displaced pets. Big Fluffy Dog Rescue — I know, how great is that name? — had teams driving through the night to bring truckloads of dogs from the disaster areas to their Nashville head-quarters. To make room for so many at once, the rescue had to find new spots for the animals already in their care. They put out a call for experienced fosters who could handle a nursing litter.

I was thrilled. I'd been waiting for a chance to foster a Big Fluffy family. Need I explain why? They had me at "big," and then they added "fluffy." Normally, the organization keeps their litters

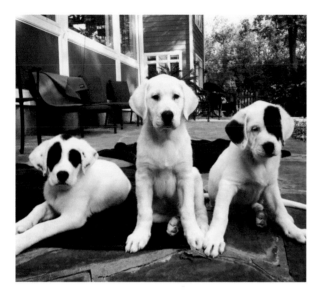

Templeton, Timothy, and Thatcher at twelve weeks

in Nashville, but this was an emergency. They'd run out of appropriate foster situations in-state.

Tanya, a Pyrenees/Lab mix, had come to the rescue from an overcrowded, underfunded Tennessee shelter as a very skinny forty-seven-pounder. They saw immediately that, despite her neglect, she was happy and waggy and loving. What they did not suspect at first glance was that she was quite pregnant. She gave birth less than two weeks later, just as the hurricanes were hitting and pushing animal-rescue groups into overdrive. As the pups reached three weeks, the whole family was loaded into the transport van out of Tennessee and up to us.

Tom and I spent our twenty-second wedding anniversary waking up at 2 AM, filling a thermos with coffee, and driving two hours to make a 5 AM puppy rendezvous in a Toys"R"Us parking lot just off I-70. It seemed creepy from a distance, but then sure enough, there was the well-lit, specially configured white van filled with crates of dogs. And there — wagging at us from her crate — was Tanya, with glorious puppies all around her feet.

She greeted us like we were her long-lost owners. It was endearing, and we were totally charmed. Suckers that we were, we didn't realize that that's just her thing — that sweet girl greets any old schmo passing by on the street the same way. We got the beautiful little family into our van, and we spent the return drive cracking ourselves up about how much fun it was going to be to have these giant puppies. At home, we got them settled into the puppy den and began to take stock.

Tanya was obviously a sweetheart and a great mom. The pups were all boys. Timothy,

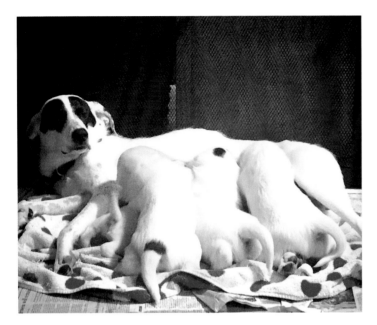

Tanya nursing the boys

Thatcher, and Templeton were already five pounds at just three weeks. That's crazy big. As for Todd, the paperwork had said he was just two pounds, so I was prepared for a runt.

Then I picked him up, and I knew. Something was very wrong. He looked okay at a glance — beautiful, in fact, the prettiest face of them all — but one touch of that body and I was on high alert. He was strangely stiff. He couldn't cuddle into me. He seemed vaguely misshapen, with a belly bulging only to the sides (not out, as would be the typical case with puppy worms). My heart dropped, and I took a deep breath. This delicious big fluffiness just got complicated.

I consulted with the rescue, and they immediately sent us for a vet visit. Everyone agreed something was off, but it wasn't yet clear what. We waited and watched. Over the next two weeks, as the other boys exploded with growth and health, the contrast with "Tiny Todd" became exceedingly clear. The stronger and more coordinated the other pups got, the harder it was for Todd to muscle in for a spot to nurse. That's always a struggle with a runt, but this was more pronounced. It wasn't just that Todd was smaller — his limbs weren't able to push correctly. As the other pups began to walk and pounce, he appeared to be swimming breaststroke, which is what led to the aha moment when a Google search led to a description of "swimmer pup."

Nobody knows why it happens, but sometimes puppies remain "flat" with their limbs sticking straight out to the side. As a consequence, their chests are compressed, which is tricky for

eating and breathing. I learned the hard truth: Breeders typically euthanize these puppies. As I dug deeper, though, I discovered that some had begun to have success with intensive physical therapy. A couple of very hopeful photos showed puppies who were flat at five weeks and normal at eight.

Mind you, I generally think nature knows what it's doing. I'm conflicted about too much intervention. I had already, two weeks in, spent no small amount of time pondering the fact that, without my efforts, Tiny Todd would already have died. At every single nursing session, I got in there to make sure he had a spot, and I stayed to make sure he didn't lose in the inevitable wrangling for a better teat. I was also supplementing his eating with a nutritious mush, hand-fed off of my finger in tiny portions because he had a tendency to choke. I had revamped the puppy den because he couldn't move on newspaper. Experimenting with rolled-up towels and upside-down bath mats, I had created traction-filled hills and valleys that could work as constant therapy.

Tiny Todd with his hobbles

What did it mean that I was keeping this puppy in the game when nature would have let him go? I didn't have an answer, but I figured, in for a dime, in for a dollar...

I followed online suggestions and made little "hobbles" that would draw his front legs together. After several failed prototypes, I was insanely proud of my refined concept: duct tape with gauze underneath, figure-eight style. I'd often have to make two or three hobbles a day, as they sometimes came off or got chewed. But it was worth it: Tiny Todd could suddenly raise himself up, put some weight on his feet, and

cover some ground. After some initial resistance — when I first put them on, he stopped try-ing to move anywhere — he seemed to realize that they actually allowed him to get where he wanted to go. Most important: They helped him join his brothers, which was all he ever really wanted.

At this point, we all just dug in for Tiny Todd. Every little bit of normal puppy life was hard for this guy — eating, moving, playing, even breathing, for God's sake — and yet we saw Tiny Todd fight for it. His giant personality started to emerge. He was going to do his part, dammit. Without that drive, the level of support we were giving might have felt wrong. Instead, because of Tiny Todd's determination, it seemed the very least we could do.

Tiny Todd playing and resting with his hobbles on

He was beautiful. He was happy. And oh my goodness did he love his brothers. At first, at three weeks, it had been easy for him to be in the middle of the slow, sleepy pack, but at five weeks, Tiny Todd had to work so hard to keep up. He'd struggle across the room to take part

in a tug-of-war that would often leave him breathless. But he'd do it again and again. He got so much joy out of his little pack. My favorite video shows him smack in the middle of three almost-asleep brothers, happily chewing on them. Mind you, they could have left for an undisturbed corner, but they didn't.

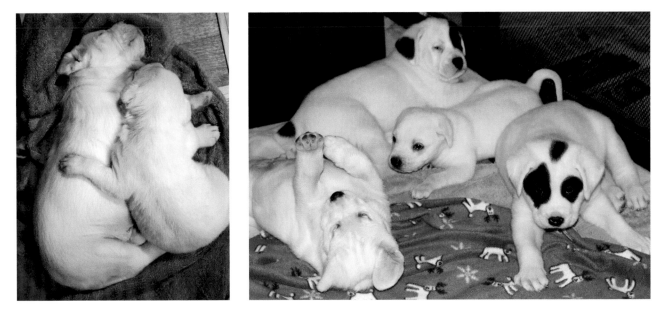

Todd always sought out a spot where he was touching his brothers.

By six weeks, the trio of giant pups was a rugby squad. They tore around the room in gleeful chaos, tackling and biting, knocking over anything in their path. There was no way Tiny Todd could join in. Sometimes he'd cry when they were playing far away and he couldn't get there. To my amazement, soon enough, I'd see one of them coming over to play with Todd. They developed a "Todd version" of their games — not rough and tumble, but still fun. They stayed in one spot and wrestled and boxed. Todd lived for it.

It was small victories, then setbacks, for weeks. It was heartbreaking to watch Tiny Todd try to cross a few feet to get to the water bowl and to hold himself upright long enough to get that

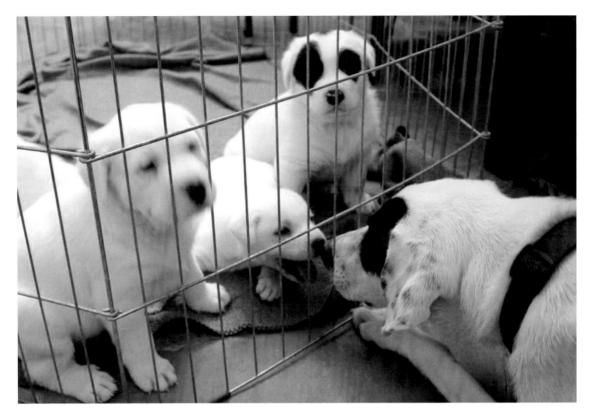

Tanya nose-to-nose with Tiny Todd

drink. I wanted so much to just move him there and hold him up. Instead, I made myself stay back, watching and rooting for him to find his own way. Then moments later, I'd see him finding his favorite toy, cracking himself up with it, playing with gusto. I'd delight as he'd happily wrestle with one of his brothers, but then cringe when I'd see how out of breath he was afterward. It was always one step forward and one step back.

Then I got the call from one of my vets who'd been consulting on the litter. "Hey, Mrs. Callahan. Just wanted to touch base on Tiny Todd. I've been talking it over with my husband, and we'd really like to adopt him if that's okay with you."

I'll never forget that call. This vet knew full well what she'd be taking on. She knew how much support he'd need in the short term, possibly in the long term. She knew she could well be signing on to be the one to determine that enough was enough. But she said she just fell for him, as we all did. That face. That charisma. She had to do it.

With that, I no longer wondered if we'd been right to intervene so strongly. Tiny Todd now had a future that made sense. He was going to a home where he could thrive.

We had a whole week where we rested in that idea. With an entirely new outlook, we watched Todd get stronger and play more often, with more vigor. He was on his way.

Then we lost him.

I was hand-feeding him that morning when he started to choke. That had happened before — we had even rushed him to the vet for it once — but he had always worked through it.

Not this time. Tom and I tried everything we could — clearing his airway, turning him upside down, the Heimlich maneuver — but it was over in a flash. In that moment, as we held him, that sweet, beautiful boy was no longer stiff. Tiny Todd's body finally relaxed into our arms, for the first time.

We only knew that puppy for a month, but he left his mark. He was the heart of the litter. The deck was firmly stacked against him, but I will never forget the way he carved out his great joys.

And to watch the youngest of souls — his brothers — adjust to his special needs was jaw-dropping. They snuggled him — especially, differently — while he slept. They came running when he cried that he was lonely. They invented new games that he could play. Less than two months old, and they did all that on their own. I think if you asked Tiny Todd about his little eight-week life, he would say it was perfect because he had the best of brothers.

Five weeks later, Thatcher and Templeton were snuggled in with their new adopters, but a robust, glorious thirteen-week-old Timothy still sat at my feet. That amazing puppy was with us for ten weeks — the longest of any foster we'd had. He was, like his brothers, everything I imagined these puppies would be when I signed on to take in a Big Fluffy litter: giant, smart, funny, endearing.

Enjoying my last night sleeping with Timmy; facing page: Tiny Todd enjoying the fresh air

Except…he was more. It was gentle Timmy I had trusted most with Tiny Todd, and it was this particular big brother Todd sought out when it was time to sleep.

When you end up keeping a dog you are fostering, it's lovingly referred to as a "foster fail." In Timmy's case, the foster-fail impulse was oh-so-strong, and yet, we suspected he had work to do. When he eventually walked out the door with his wonderful new family, I smiled. They had no idea — yet — how much grace his big, empathetic heart would bring to their lives.

As for Tiny Todd, who brought out the best in all of us: Rest in peace. I trust you are finally romping around with no need for those hobbles and taking nice, easy deep breaths.

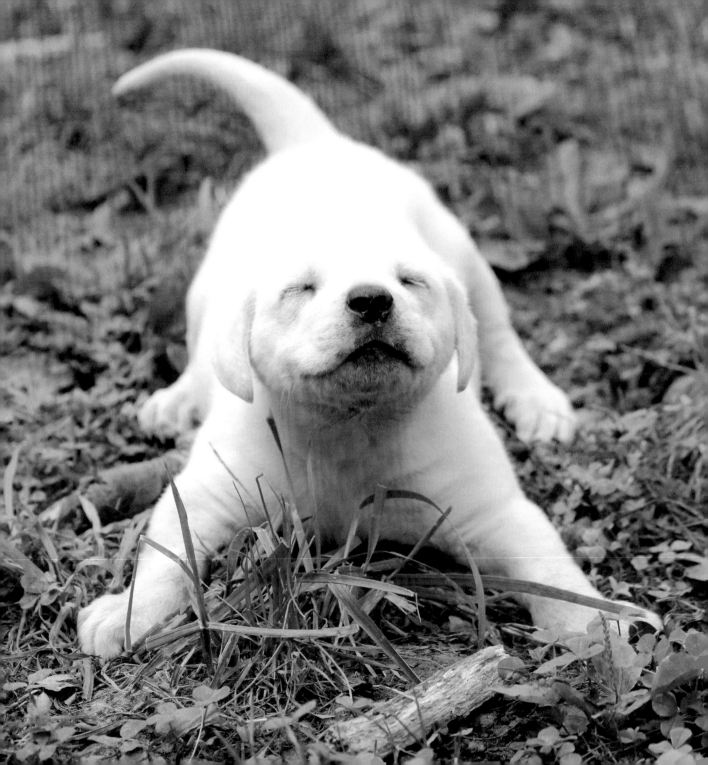

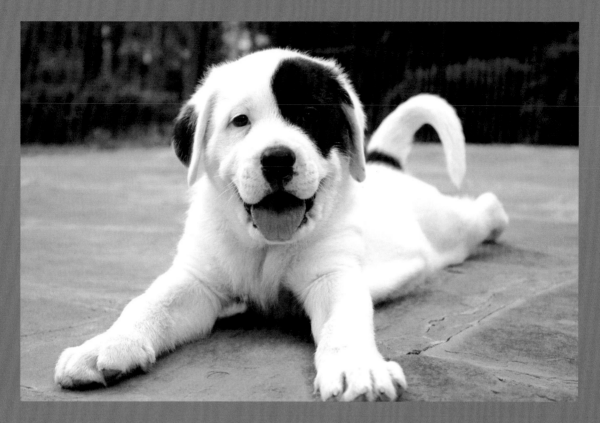

LOVED BY
THE VILLAGE

Thatcher was a giant ball of photogenic charisma. He and his brothers had captivated my Facebook friends as they romped and wrestled their way into adoption age.

Thatcher ended up right in the 'hood, with a great couple. As they'd walk their new pup, cars would slow, windows rolling down, and voices they didn't know would enthusiastically call out, "Hey! Isn't that Thatcher?" At their boys' baseball games, strangers would make a beeline for them, squealing: "Oh my gosh, it's Thatcher!" At the pet store, suddenly, "No way! It's Thatcher!" would ring out, followed by introductions and hugs.

The beautiful message: These pups — who'd had a rough start — had a whole village delighting in their happy ending.

THE GLORIOUS GOAL

Every foster pup who comes through this house wants this moment. Eli does not allow it right away. He growls off their rude puppy enthusiasm for a few days, or as long as it takes until there is the deferential approach he's after. Once a pup learns to be respectful — like this little foster, Johnny — the sought-after cuddle into the glorious fur is permitted.

Chapter 10

THE PUPPY WHO WAS RETURNED

Way back in the beginning of our fostering adventure, there was a puppy who took my breath away the second I saw her. She looked like a little black wolf and was the spitting image of one of our old dogs. I wondered how that simple, powerful thing — a physical resemblance — would affect my husband.

Tom has a type. A beloved-dog type: wolfy, smart, sensitive, deep. Two of these special souls had been a part of our pack. Kela was Tom's girl when we first met, and later Zoe moved into that spot in his heart. When we started fostering, Tom was still shaken by Zoe's recent death, and he had made it clear he wasn't ready to bring a new dog into the pack.

The fact that the new foster pup looked "like a Callahan dog" wasn't lost on our four-year-old niece, who suggested the name Callie.

This one had the feel of fate, and I sat back to watch.

Right off the bat, there was competition for Callie.

We still had foster puppy Prim, who had been with us a few weeks. This dear, shy Lab mix had come into rescue all by herself, with no littermates. The moment Prim saw Callie, she was

Baby Callie with me after her first bath (bottom left) *and snuggling with Grace* (bottom right) *and Eli* (top)

over the moon. She simply could not get enough of her new friend. She taught Callie "chase" and tug-of-war, gently suggested various toys, and curled up next to her to sleep. In fact, she swooped in and claimed that pup to the point that we barely got to play with her.

A week or two after Callie arrived, Tom and I had a wedding to attend in New Orleans. My brave sister, Kris, agreed to come look after our two daughters and the entire furry menagerie. Kris had expected to fall in love with Prim after ogling her on Facebook for weeks. But that weekend held a surprise: The puppy she bonded with was Callie. Her hilarious email updates bemoaned the fact that she was employed — since the one stumbling block to her family adopting a puppy this young was that they weren't home enough.

Baby Callie with foster Prim — the two were inseparable.

On Sunday night, we flew back and drove straight to the rescue headquarters to fetch Callie, who'd been taken to an adoption event there. When we walked in, we found a distraught and teary group of volunteers. My heart started to pound.

Callie had gotten tired at the event, so they had moved her into the volunteer office for a little nap. A second, bigger dog had also been brought into that room to take a break from the busy scene. It was quiet and peaceful for maybe half an hour, but then, out of nowhere, the big dog attacked the sound-asleep Callie. It only lasted a second, with people intervening immediately, but the damage was done: A terribly injured Callie was rushed to the emergency vet.

"She may not make it," they said.

Endearing Callie, recovering in her baby T-shirt

I know what you're thinking: *How could this happen under the supervision of dog people at an official event?* I was angry, too, but years later, I see it very differently. My take now is the following: It is extraordinary that this kind of split-second disaster is so rare. Every day, rescue groups handle thousands of dogs who are as stressed as they will ever be — uprooted, in transition, moving from shelter to van to foster home to event, surrounded by humans and dogs who are utterly unknown to them. They make it safely, without incident, into new lives 99.9 percent of the time. That's thanks to the herculean efforts of so very many people devoting their free time, developing their dog-handling skills, and perfecting rescue protocols. Every now and then, of course, something happens.

After a day or two on pins and needles, we got word that Callie was going to be okay. My adoption coordinator was wryly calling her the "million-dollar pup" after the rescue paid the three-thousand-dollar bill. Callie was shaved over half of her little body and sporting Frankenstein stitches. For the next week, she had to wear a little baby T-shirt to keep those wounds clean and dry. She looked ridiculous and utterly endearing.

The recovery period was probably hardest on Prim. That sweet girl was dying to wrestle with her friend. She and Callie spent two weeks playing creative games through protective crates and gates. When finally Callie was well enough to romp again, the two of them were off and running.

After all the chaos — wedding, attack, recovery — we might have found a sane moment to ponder adopting this pup.

Injured Callie playing with Prim through the protective gate

But instead, an application arrived that looked fantastic on paper. Further interviews turned up no reason to say no. Before I knew it, I was dropping off that beautiful puppy. It did not feel quite right, but I chalked my emotions up to being too protective of this could-have-been-a-Callahan.

Two months later, I got a call from the rescue that Callie was back. She'd been returned. Somebody in the adoptive family, it turned out, was "allergic."

That poor baby. Of course, we took Callie back to our house to foster. She had been through too much change already.

While she was away, she'd become a breathtakingly beautiful dog, her coat now streaked with silver. Even more striking was that she had matured into the "pointy" personality that had been hinted at by those wolf/shepherd ears: intelligent, alert, sensitive. There was now an emotional depth to her that was impossible to miss. The girls and I couldn't get over her. Being around this dog was so very much like being around the now-departed Callahan dogs who'd been closest to Tom's heart. After we missed our first chance at adopting her, was the universe sending a message by landing her back in our house a second time?

Turns out, the universe was speaking to someone else! My sister, Kris, was back. She hadn't

My sister, Kris, and I live less than an hour apart, and the human and canine cousins all rejoice in our gatherings. Left to right: Grace is with our Nala and Rocket; nephew Jack with Callie (now Kala); niece Kara with Ellie; Claire with our Mojo; and Jack's girlfriend Catherine with our Eli!

forgotten this puppy. And now — thanks to that two-month failed adoption — Callie was old enough to be adopted to a household with people off at work and school most of the day.

Kris was all in, and fast. The only remaining question was whether their current dog, Ellie, a yellow honey-I-shrunk-the-Lab sweetheart, would take to this potential new packmate. I drove Callie over to my sister's house with bated breath. When the door opened, Ellie zoomed out. The immediate, exuberant play made it seem like she and Callie had known each other forever.

In a glorious turn of events, those two have now been playing just like that for four years, in a pack where they are adored by their people. As it turns out, Callie *is* a Callahan dog. I just had the wrong branch of the family in mind. Our holidays now always include a happy, beautiful wolf-dog cousin who — like us — is thrilled about the reuniting of the extended pack.

As for Callie's mentor Prim, we had her for a longer-than-usual six weeks while we were still very new at fostering. Translation: That's a recipe for a hard goodbye.

Thankfully for us all, Prim was adopted by dear family friends who live just ten minutes away. Even so, I managed to "forget" the adoption contract when I went to drop her off, and we all laughed because it seemed pretty clear I wasn't *quite* ready to let go.

Claire, cuddling with foster Prim, who was eventually adopted by Claire's friend

Prim

At our house, Prim had been scared of men (even growling at Tom, which is unheard-of). She had also been, rather amusingly, terrified of a collar. Every time I'd put one on her, she'd flatten to the ground, as if magically paralyzed by it. We never made much progress on either of those issues, and I tossed and turned a bit about our friends having to deal with all that.

A week after the adoption, I stopped by to visit. Imagine my surprise when I watched Prim enthusiastically greet her new six-foot-seven dad, while romping with a big old collar around her neck.

Yet another lesson from fostering: Stop worrying so much. You don't have to solve it all yourself.

Why Training a Dog
to Pee in Only One Spot Is Tricky

As delightfully as Callie's story turned out, there's one part I can't stand to think about. She was an incredibly smart, trainable dog. Yet for a very long time, she was not fully housebroken. She would poop on my sister's family-room rug in the middle of the night. She would refuse to pee on-leash. She once endured a nine-hour car ride without relieving herself at rest stops.

The first time Callie was adopted, the people confidently told me they were going to train her to "go" only in one spot in order to avoid yellowing the grass. I didn't know enough back then to articulate how tricky that is.

The puppy didn't learn the intended lesson that "this corner of the yard is the spot." Instead, the puppy learned: *Whenever people see me eliminate, they get mad at me.* Thus, months later, in a different home with different people, this stressed-out dog was sneaking around to poop when everyone else was asleep and holding in her pee during an on-lead walk.

Long-lasting housebreaking issues are very frustrating. Thankfully, Callie ended up with Kris, who thoughtfully pondered things from the puppy's perspective. Basic positive reinforcement — treats and praise for peeing outside — eventually did the trick. Of course, in a two-dog household, you can't set up a regimen like this for only one dog. Kris reported that Ellie, who'd been perfectly house-trained for years, loved this phase, clearly thinking: *We get treats now for peeing? Fantastic!*

Sweet girl Callie, now Kala, at home (photo taken by my niece Kara)

Chapter 11

MIRACLE ON THE COUCH: THE BIRTH OF THE HUSKADORS

My nesting was at a fever pitch. Tom was used to my happy bustling the night before a litter arrived — setting up the puppy pen, gathering supplies — but this was at another level. Why? Because this wasn't just a litter. It was our first pregnant mom.

In the midst of that frenzy, I stumbled onto a website optimistically named EZwhelp.com. I was putty in its hands. Did I want the "Fab System Whelping Box"? Yes, please. And the heat lamp (since, as the write-up described, hypothermia can kill newborns at room temperature)? Um, yes. And the rail accessory (to keep mama dog from smothering her pups)? Oh my goodness. That online cart was bursting at the seams.

I was determined to be ready for this mama-to-be.

It might help to explain that I had just become an empty nester. A week earlier, we had dropped off our second daughter, Claire, at college.

Funny how there's that resentment in the early kid years — *When will we get our life back?* — but then the kids actually become your life. And then they go away, and you wonder when your life will come back to visit.

This was my post-college-drop-off distraction plan for September. Normal people might get a puppy, but of course we have puppies all the time. Even taking in a big litter wouldn't do the trick — been there, done that. This time I wanted something new. Something challenging enough to remind me that exciting new things await on the other side of the everyday-parenting life.

Beautiful Piper looked like just the ticket. According to the email plea, this black Labrador retriever had just come into a shelter, pregnant.

I'd long been drawn to the idea of giving a mom a safe place to have her babies, but I was scared. So much can go wrong during the birth and during those fragile first weeks. However, we were in our sixth year of fostering. We'd finally, sadly, been weathered by loss. I now knew that we could get through it if the pups didn't make it.

With a sense of great anticipation and a little prayer to the universe, I said yes to the pregnant mama and her bulging, promising belly.

Proud mama Piper with her newborns — on her beloved couch

Piper looked like a purebred Lab, and indeed, it appeared her owner had been breeding with her. When he dropped her off, he apparently said: "She's blessed us with over fifty puppies." No wonder this five-year-old girl had started to go white around the muzzle. Most of her life had been spent pregnant or nursing.

Whether he knew it or not, the owner had put Piper and her pups-to-be at tremendous risk with that drop-off. First of all, Piper had not been vaccinated for rabies or distemper. Vaccinating her on the spot would give protection, but it carried a risk to the unborn pups. Second, if the pups were born at the shelter, they'd be exposed to life-threatening diseases their undeveloped immune systems were not equipped to fight. Finally,

despite the fact that the owner remarked she was "great with dogs, kids, and cats," he was giving her up to an underfunded shelter — one that was sometimes forced to take the heartbreaking step of euthanizing because they simply did not have enough adopters for all the animals who streamed into their doors. Did he not understand that Piper could have been put to sleep?

It was perplexing on many levels, including the practical. He'd presumably been breeding Piper to make money. So why not keep her until these pups could be sold? One theory was at the top of my list: The father of this litter was not from the right family, and therefore the pups would be "worthless." We'd soon see.

I had a long list of concerns on Piper's behalf, but Piper herself held no grudge. She had just been kicked out of her home and had landed in a concrete pen in a loud shelter. She was stuffed in a crate for a multiple-leg drive with two sets of strangers. Last, she was unloaded at our house, where four big barking dogs came out to see who was coming onto their property.

And she was hugely pregnant.

She would have been forgiven for being scared, testy, shy, or aggressive. Instead she was… waggy. We just laughed. That tail spoke volumes, and it never stopped. Thump thump thump. Whack whack whack. Swish swish swish. Piper's good nature was on display in our house from the very first moment.

Having Piper in our pack was a breeze, but what *was* difficult was the waiting. Our psychological red-alert status was in place from the get-go. We chose the twenty-year-old van instead of the nice car for the drive home from our rescue group's adoption center, just in case she had those babies during the ride. Once home, I watched her every single minute for the panting and pacing that is supposed to indicate the start of labor. Every night around 2 AM, Piper would spend an hour or two just panting in my face, sitting up in bed, staring at me. Each time, I was sure that this was her signal, this was the hour. Inevitably…nothing.

That got old. After ten days, I stopped obsessing and began treating her as just part of our pack. She cheerily explored the yard with all the dogs. She gently befriended the cat. She jumped up on the kitchen island (all four feet!) to snag some food. She snored in bed, draped across us. In short, she became one of the gang.

No longer all vigilance, I was totally absorbed watching CNN one afternoon when I looked over to the other end of the couch and saw Piper calmly guiding a puppy out of her body.

Yep, on my couch. So much for the brand-new high-end whelping pen I'd spent hours examining, assembling, rearranging. Piper preferred the couch, which for good reason was typically covered in a dog-friendly blanket. Now, at the moment it mattered most, that stupid blanket had slipped down. Piper was giving birth on my upholstery. I took a moment to thank that cushion for all the sleepovers, the movie nights, the Odyssey of the Mind team practices. I decided then and there that this birth would be the cushion's crowning moment, and it would hit the curb soon afterward.

Other than the upholstery mishap, I was ready. Plenty of reading and YouTube videos had taught me what supplies I needed and what to watch for. I was ready to help pop the sac (ever so carefully) and cut the umbilical cord (at just the right spot) with my special new scissors. I was on deck to suction the mucous from a little mouth with my brand-new bulb. I had my washcloths in a pile, ready to massage the pups into breathing.

The EZwhelp pen finally in action

Those things are all in pristine condition for my next pregnant mom because Piper was a pro.

As I held my breath, astounded, she finished pushing out puppy #1 without a groan, quickly made that sac disappear, expertly licked the pup into breathing, and ably chewed that tough cord away. Five minutes after that miraculous shimmering ball slid out of her, a clean, dry, unfathomably capable puppy was happily nursing from this very calm mom.

As we hung out on the couch, I split my time between trying to fully absorb this miraculous moment and

eyeing the EZwhelp pen. I had to get her in there. Horrors, primarily of the suffocation variety, abounded on the couch. That squishy surface could make pups roll down and under mama. The cracks where the cushions met could lodge a newborn. There was also the potential devastating drop to the floor. It was time to move mama and puppy #1.

I gently reached in and moved the pup to the pen, encouraging my sweet girl Piper to follow. Of course she did, in a split second. Perfect.

Then Piper grabbed her newborn by the head, making the pup squeal in terror, and roughly brought her back up to the couch, practically sitting on the baby as she reclaimed her spot. Piper then stared, deadpan, at me. The ever-present wag was gone.

I opted to wait on the move.

Even though I knew labor could take a long time, my brain stubbornly expected the pups to come quickly one after the other. Pup #1 arrived around 1 PM; by 3:45, there was still no second pup. While I was relieved Piper was relaxed and her puppy was nursing, I started to worry.

Then Piper sat up, breathed hard twice, and welcomed pup #2. Again: the shiny ball, the calm dispensing of the sac and all the extra, um, material, the licking-into-breathing, the nursing. Like I had the first time, I pitched in with a little bit of drying and arranging (to make sure neither pup fell into a dangerous couch spot), but generally my "usefulness" was in the areas of encouragement, water, and snacks.

Pup #2 confirmed my earlier suspicions: Daddy was not from the right family and had gotten Piper booted from her home. While the first pup looked perhaps like a black Lab, this little boy had darling white markings. I smiled at that white blaze and thanked it for spiriting this gang into our house.

The next hours-long gap with no birth was less worrying than the first had been, since I figured this was just Piper's rhythm. Sure enough, by 6 PM, the birthing couch was host to three happily nursing one-pound pups. Content, filled with relief at how things were going, I sat back to await the delivery of pup #4, presumably at 9 PM.

But that didn't happen at nine, ten, or eleven. We were now well into dangerous territory, according to the death-is-around-every-corner internet. Apparently, going past hour four

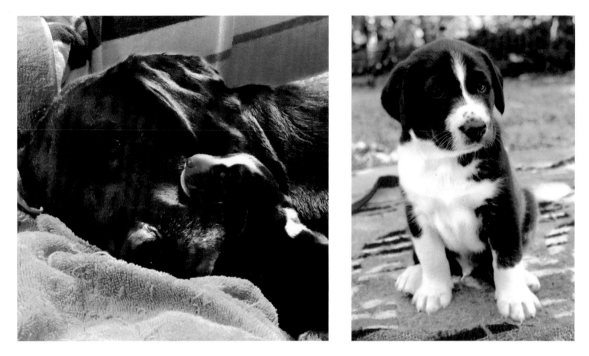

Spokespuppy Puffin as a newborn and a five-week-old

indicates a pup may be in a difficult position or in a bad way, and mom could be in danger. I took advantage of my phone-a-friend option and was in constant touch with my contact at the rescue group. She sent my videos of Piper (clearly not distressed) to a vet tech, who said it appeared Piper was done.

That seemed impossible to me. First of all, Piper was too big, and second, Tom and I had spent the past week feeling those pups moving around. No way there were just three.

Here was the exact situation I'd feared and the reason I'd never taken in a pregnant dog. As midnight approached and labor reached close to twelve hours, something appeared to be wrong. If I didn't take action, was Piper at risk? Should we load her and these fragile newborns into the van and drive them half an hour to the (germ-laden) emergency vet? Given how the move to the pen had gone, I shuddered at the prospect.

Piper's demeanor — ever calm — was the deciding factor. I took a long look at her and chose to adopt her vibe.

Sure enough, just after midnight, pup #4 arrived, appearing perfectly healthy. Around 3 AM, pup #5 joined her littermates, and finally, at 5 AM — sixteen hours after she'd started labor — no-drama-mama Piper delivered the fifty-sixth and final puppy of her life. Her days as a breeding machine were over, since all rescue dogs are spayed or neutered.

All I wanted to do was sit and marvel at the little mewing and suckling sounds and watch Piper gently lick her babies. Alas, the couch situation was a genuine emergency. I'd been able to allay my falling-to-the-ground fears by building up little cushion walls, but even as Piper kept giving birth, her already-born pups kept rolling under her and getting trapped every time she moved. I would then shift that most unwilling sixty pounds to retrieve them.

After the initial attempt, Tom and I tried twice more to encourage Piper into the whelping den. Each time, she reacted with the same shockingly uncharacteristic panic and the weird lack of gentleness as she grabbed the puppies to relocate them to the couch.

In the end, we decided the only answer was to make the couch unavailable. Tom and I quickly moved the pups and blocked off the couch using a pen. This led to half an hour of panic, first from Piper but quickly spreading to me. Would she relax enough to nurse and care for her newborns in the pen? Would she forever lose her trust in me?

At last, Piper gave in. She nursed the pups in the pen, and we were over the hump. Even so, we waited days before removing that fencing, and even then we kept the cushions off of her cherished couch so it didn't beckon to her.

The next order of business was to try to get a handle on who exactly we had. There were two boys and four girls, all mostly black but with enough subtle differences that my scribbled sleep-deprived, post-birth notes could identify all six pups. The critical reason for being able to tell them apart is so that you can weigh them once a day to make sure everybody's gaining. The fun reason is so that you can get to know them and recognize patterns in behavior, ideally by identifying who's who at a glance.

To help with this, I took the colorful thread the girls once used for friendship bracelets and

tied a different colored necklace around each newborn's neck — loose enough to be comfortable but tight enough not to get caught on something.

Then it was time for names. Because they were our Empty-Nest Litter, we went with a bird theme. The boys were Puffin and Jay, and the girls were Raven, Magpie, Starling, and Chickadee. They were mostly the glossy black of their mama, but there were some darling white mittens and socks, some eye-catching brown eyebrows, and a few white markings on chests. Theories on the father's breed came flooding in. Eventually, I couldn't resist: I did a DNA test on Jay, which revealed dad to be a purebred husky. I suspect Piper's former owner bred both Labradors and huskies, and his containment systems just broke down for a moment.

It was official: Puffin, Jay, Magpie, Raven, Starling, and Chickadee were the huskadors.

So attentive was Piper that I truly think she did not sleep for the first seventy-two hours. When I finally saw her snoring while the kids were nursing on day three, it struck me that I'd never seen a more well-deserved snooze. You thought childbirth was tough? Try delivering your sixth kid while the other five are nursing, and then spend the next weeks obsessively feeding/cleaning/stimulating your sextuplets all on your own. I was in awe.

In one area, though, Piper didn't quite earn the mom-of-the-year designation. She kept

Determined little Chickadee (left) *and handsome hunk Jay* (right)

lying down on top of a newborn or two. This happened a handful of times in every twenty-four-hour cycle. This is not unusual, which is why those raised rails along the side of the EZwhelp pen are literal lifesavers: They give a trapped pup better odds of being able to squeeze out from under mom. If mom is right up against a corner, that's the end. That's right, newborn puppies die all the time because their moms accidentally suffocate them. How's that for a different view of having puppies in the house? Basically, I didn't leave that den for weeks, constantly counting to six, and performing a sweep if I only got to five.

More often than not, as time went on, tiny Chickadee, the runt, was the victim. Within a week or two, the others grew strong enough to escape, but not Chickadee. In the end, her smarts rather than her strength allowed me to relax. I noticed that she started to keep an eye out for her mom's scary descent and would scuttle out of the way with speed that looked way beyond the capability of that little body. Clever girl. At last, after about a month, I started sleeping back in our actual bed, no longer worried that I'd be absent for the one critical moment.

I worried about Chickadee for another reason, though. The daily weigh-ins revealed five pups gaining like gangbusters, but on some days, sweet, spirited Chickadee didn't gain at all. It was mysterious because she was energetically nursing and often finding the best teat. Was she unable to suckle effectively? Did she have a cleft palate or the dreaded megaesophagus (a disorder where the esophagus loses its ability to push food to the stomach)? I worried even more when I realized that more often than not after nursing, she had milk coming out of her nose, causing her to sneeze and choke. As always, googling spelled doom.

I steeled myself for another Tiny Todd, the unforgettable runt we'd lost the previous year. Like him, Chickadee was charismatic and determined — the first to open her eyes, the first to pull herself up to walk on all fours, the bravest explorer of unknown territory. I adored her, and for a month I was on pins and needles, doing whatever I could to support her.

As we approached weaning time, I knew this could be make-or-break for this dear baby. Was she just barely hanging on with nursing, and the switch to solids would reveal major problems?

In fact, it was the opposite. Chickadee took beautifully to warm mush, and the giant upside was that I could feed her whenever I felt she needed it. It became clear that her gurgling and choking was directly related to nursing. Once she could simply eat on her own, that daily weigh-in became a little triumph.

Newborn ears are sealed shut (left) *and open when pups are about two weeks old* (right).

Of course, I knew the pups' eyes wouldn't open until the second or third week. What I did not know was that their ears wouldn't open. Seriously. Newborn ears are sealed shut. Check out the photos above; you can see there is simply no opening at first, and then, boom, after a week or two that canal magically appears.

Alas, that meant the huskadors hadn't heard Tom singing little puppy songs to them all along . . .

As for the eye opening, this wasn't my first time witnessing that little everyday miracle. However, both Daisy's and Mojo's litters were newcomers to our house when that happened. This time — with the in utero time, the delivery, and two weeks of 24/7 sleep-deprived cohabitation — it felt like we'd already spent a lifetime together by the time those eyelids finally decided to unseal. I remember Puffin's emergence with startling clarity. I thought I saw his eyes cracked open a bit, so I picked him up and cradled him for a closer look, and he directly held my gaze with unimaginable intimacy. I kid you not: This had the same blow-you-away, "Oh! It's you!" mutual recognition that I felt looking into my newborn daughters' eyes for the first time.

Hmm. Maybe let's not tell them that.

Once we hit the one-month mark, it was time for the socialization shenanigans that I've come to love. Maximizing a puppy's critical socialization window is one of the best opportunities with this kind of fostering. It's easy to create a stream of positive encounters with lots of strangers, and

that experience at this tender time will carry over, helping to "vaccinate" the pups against being skittish with people. I invite folks to sign up to hang out with the pups and me for an hour. I make sure no outdoor diseases come into the safety of the den (shoes stay out, and so on), and there are strict rules about holding (only when sitting on the floor, only a willing pup). The pups get used to new voices and smells. The people hear a bit about rescue. Often, some great homes are found. Usually, it's a win-win-win.

Interestingly, Piper was the first mom I've had who felt a bit uncomfortable with these puppy visits. The main sentiment from other moms, as I slowly allowed strangers near the den, was: *Sure, knock yourselves out.* But Piper — the easiest, friendliest dog — was stressed out by this. She'd stick very close, and then if someone picked up a pup, she'd loom, or even give the offender a bump on the puppy-holding arm with her nose. The minute people backed off enough from her pups, she returned to her waggy, welcoming self.

My theory is that Piper's pups were taken from her too early in the past, and she didn't want that to happen again. (Eight weeks is the magic number.) I bet her previous owner opted to get the cash earlier, and ditch the work sooner, and it didn't feel right to Piper. So we took it slow, with fewer visits and more space between visitors and pups, and soon enough Piper realized all was well.

In addition to some careful handling at our house, I took the huskadors on several field trips without

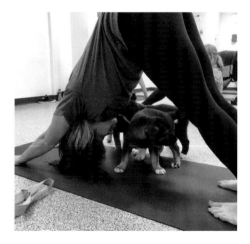

The huskadors spreading joy at preschool (top) and "puppy yoga" (bottom), where they helped raise money for rescue work

Magpie (top); *Starling* (bottom)

Piper. Foster litters like mine sometimes pay it forward by being adorable fundraisers, so that groups like Homeward Trails have the funds needed to rescue the next set of pups. The huskadors spent an hour at a DC public relations firm whose boss "bought" us as a surprise for her employees. They were the stars at "puppy yoga" one night, meandering adorably through the mats filled with people who paid extra for the experience. And they filled a bunch of kids with glee at the preschool where I used to teach. All those experiences made the puppies' worlds bigger and readied them to head out from the nest.

As an aside, we are careful to keep the not-fully-vaccinated pups safe from exposure to disease by bringing floor coverings, carrying pups so paws don't touch the ground, washing hands, and not letting pups chew on shoes!

By week six, the personalities of the huskadors were exploding:

- Jay, the even-keeled hunk
- Puffin, the engaging spokespuppy
- Starling, whose one blue and one brown eye mimicked her double personality: the very sweetest of snugglers and the wild child
- Raven, the brainy leader
- Magpie, the mature, all-around gal who thought of herself as a peer of the big dogs, rather than her littermates
- Chickadee, the determined runt with a giant Facebook cheering section

Did I mention they were beautiful?

After eight weeks of Tom and I having a ball with every phase of this, it was time to say goodbye. Alas, just because we're used to it doesn't make it easy. What helped, though, was knowing they were each going someplace wonderful. This litter set a personal record for me: They never even had to go onto Petfinder.com, which is where shelters and rescue groups post their available pets. Piper's pups were all claimed by my own Facebook world, by friends of friends.

All-grown-up Raven, Puffin, and Chickadee catching up on a playdate at our house

While I came to love each of the families who opened their homes to a huskador puppy, one placement had me over the moon. Our friends Roly and Cindy lost their beloved hound the previous spring. Soon after, Roly came over to donate all her things to Homeward Trails. We had a teary talk about what a wonderful dog she was and how lucky it was they ended up together. But unbeknownst to them, I did not, in fact, donate their dog bed to Homeward Trails. I knew their family would not take long to decide that dog-less is no way to live, so I saved the bed for them. Then I "borrowed" it for the pen where Piper slept with the pups. Now the bed's back with their family because they have a new dog who is very familiar with that bed. When we visit Roly and Cindy, Piper is delighted to see us, but there's no doubt in her mind who her people are. She is now home.

THE GATEWAY PUP

Some puppies capture the public imagination, resulting in a shocking number of "oh, if only we could adopt" comments on Facebook and Instagram. Mulberry was such a pup. With the one-two punch of his supermodel gaze plus his endearing litter leadership, he earned a legion of fans — plus a book cover!

One such devotee was the daughter of friends who were not dog people. Nevertheless, their child would announce, after every post, some variation on the theme that life as she knew it would come to an end if Mulberry did not become a member of their family. It was a daily battle, with our friends forced to articulate, over and over, their solid reasons not to get a puppy.

Then Mulberry was adopted by somebody else. There were tears, regret.

Six months later, Tiger — Mulberry's doppelgänger — landed in our house, and in about a nanosecond, theirs. Four months after that, Lola made the identical journey.

Our friends are now dog people. I believe it is thanks to Mulberry, the gateway pup.

"I LOVE YOU, MAN."

Adorable drunkards. Those two words don't typically go together, but watch a litter of four-week-old pups (like Mulberry's brothers Aspen and Birch), and that's what you'll be thinking.

Chapter 12

A WORD ABOUT POOP

People assume the worst part of fostering must be the goodbyes.

No, my friends. If only that were true.

The worst part is the poop.

Before you get all glassy-eyed about the beauty of fostering a litter, let's just make sure you are crystal clear on what can happen in the morning as you greet your four-week-old puppies.

The night before, I tuck the little darlings in sometime around ten. That means we spend half an hour gently playing while I chat with them. There is a bedtime snack. I put down freshly laundered bedding, replace the newspaper, refill the water dish, turn on a night-light, kiss them on their dear heads, and go upstairs.

Sweet, right? Yes, the nighttime is lovely.

Then the morning comes.

First, there is the bleary-eyed moment of internal debate in the kitchen: coffee before or coffee after? Truly, I need the coffee to face what awaits me. And yet, if they hear the house stirring, they will be up and running around. Every extra moment of running around is a very bad thing.

I gird my loins and open the door to the basement. There's one quiet moment when they're (I'm sure) cocking their heads, listening . . . and then all hell breaks loose. *The Lady is on her way!* They are chirping, calling, scrambling over newspaper just so that they can smoosh up against the pen to greet me.

The question is: Just how much poop did they run through to get there?

At this point, I would like to incant "Immobulus!" like Hermione in *Harry Potter* and see them freeze. Then I could size up the damage, plan my attack, and minimize collateral poop-mushing with a quick and efficient approach.

Regrettably, I am not a wizard.

If I have opted *not* to have coffee first, I often snag my foot a little as I step over the tall pen and inevitably land in poop as I recover. Those are the days when the swearing starts early.

I know I should greet the little stinkers, but they are biting my feet in excitement, which makes me move too fast and step in more poop.

I bunch up the yucky newspapers into a newspaper-poop-and-pee ball. That draws their attention away from my feet (a plus) but only because they now tear at the newspaper ball like a toy (dang it). I extricate the disgusting mess with my bare hands. There is more swearing.

Using a plastic grocery bag, I try to snare a stray poop on a towel, but I'm too slow and somebody grabs the bag. Now I have to retrieve the bag before it kills a puppy by blocking an airway. As I scramble to get that plastic out of that puppy's mouth, I practically kill several other puppies by accidentally stepping on them because they will not move even an inch away from me.

Mind you, this is the easy version. While mama can normally come and go from the puppy area at will, she is kept out during morning cleanup. The Advanced Morning Poop class is when some upstairs system breaks down (there's an open gate or a door ajar), and mama dog comes tearing in.

Is this an endearing moment? Is she just so darned eager to see the kids? Oh no. She is searching for 1) leftover food tidbits the kids didn't eat the night before, and 2) poop. Yes, she and I enter a race to see who will "clean up" the poop first. I am desperate to keep her from

eating it because, while it's natural when the babies are really young — that's how mamas keep their dens clean — it just seems grim as they get older.

Therefore, mama and I dive around the poop-and-pee-covered floor — kind of like kids after the piñata breaks — as the puppies swarm us both. Her extra energy and speed dramatically increase the likelihood of the dreaded poop-spread-by-foot.

Swearing reaches its zenith.

Half an hour later, the den is peaceful and clean. The first load of towels is in the washer. The trash bag is out in the bin. Fresh papers line the floor, and new towels cover the carpet. Any dirty pups have been cleaned with a warm washcloth, and all have eaten a nice breakfast. I have a nice hot cup of coffee in hand.

Once the ground is safe, I sit and give the little guys what they wanted all along: a good-morning wrestle/snuggle. They missed me. As all that delicious fur burrows into my lap, making me smile, I glance up. About three inches from my face, somehow stuck in the air on the wires of the pen, is a glob of poop.

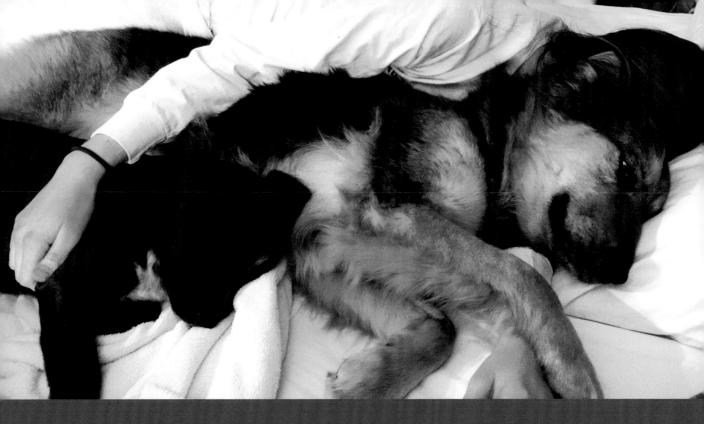

LAST PUPPY SYNDROME

There is always a last puppy. Littermates are adopted one after the other. People keep picking somebody else. Finally, only one puppy remains.

That's when Last Puppy Syndrome (LPS) sets in, and it explains why foster puppy Tuesday was in a second-floor bedroom — not a place we share with a whole litter of puppies — spooning with our dog Nala and our daughter Grace.

No way do we let a last puppy sleep alone in the now-sad den, the now-lonely crate. Up he comes, into the pack. Without all the other pups in our hair, we can focus on him. We teach him to sit. ("Wow, he's so smart!") We introduce him to a leash. ("He was perfect, just trotted along!") Of course, he sleeps up in bed with us. ("He settled right in, and didn't wake until 6 AM!")

Inevitably, we come to know: The last puppy is the pick of the litter. Happens every time. That's LPS.

BUT WHAT ABOUT YOUR KIDS?

Folks often tell me they'd foster except for the fact that giving up the pups would break their child's heart. I suspect they're selling their kids short. Even the youngest of souls finds joy in doing good. Claire felt so satisfied when we got photos of this favorite foster of hers, Paprika, snuggling on the couch with her little girls.

About the Author and Her Original Pack

THE HAPPY CRUCIBLE

Of course, it was because of a dog that Tom and I got married.

It was also because of a dog that we almost did not.

I had taken my puppy, Ben, to our happy place, Lincoln Park on Capitol Hill in Washington, DC, when Tom came walking through. He was heading to a Rolling Stones concert, but he couldn't ignore the gorgeous Bernese mountain dog bounding over to him. He looked up, we recognized each other from college, and he asked for my number.

That summer, my dog had been my sole trusted companion. I was feeling skeptical about the human race, after one of its males had let me down rather dramatically. Puppy Ben and I were living in a fantastic little carriage house in the Eastern Market neighborhood of DC, and that dear dog was coaxing me joyfully back into the world. Our walks took us to the lawn of the Supreme Court, the gardens of the National Gallery, the steps of the Capitol. Back in our cozy house-for-two, he was never more than a foot away and always meeting my gaze. I was utterly content.

A few blocks away, Tom was living with . . . wolves.

How does a guy end up living blocks from the Capitol with two wolves as pets? It starts with an ad in the *Washington Post* offering a "wolfy-looking pup." That drew Tom to visit the litter

out in Virginia, where he was intrigued by the pitch about the wolf dad and German shepherd mom. Yes, he later learned that wolf hybrids are not a good idea, but at the time he was all in. He brought little Shadow home.

The next year, amazingly enough, Tom wasn't the only clueless, single thirty-year-old guy on his block with a wolf hybrid. Right across the street was Dave and his beautiful Mojo. (Our current Mojo is named in part for her.) In a move that makes us shudder now, Tom and Dave enabled Shadow and Mojo to become parents to nine adorable pups.

All of this explains how, when I ran into Tom, he was living with two wolf-dogs: Shadow and his puppy daughter Kela. On our first date, I thought it was odd that Tom kept saying, "We should get our dogs together to see how they get along." After all, my perfect little Ben had always gotten along with every dog he met. Tom and I were both inexperienced owners at the time, and it showed.

Date number three was to be a frolic with our dogs at Stanton Park, where locals brought their dogs to play off-lead. I arrived early with Ben. Then came Tom, with his two jet-black wolf hybrids. In one instant, shocking to me, Shadow made a beeline for eight-month-old Ben. There was yelping in fear (my boy) and fur dangling from a mouth (his boy).

I remember no details — only my fury. Tom, however, recalls me glaring at him as I stomped off, seemingly forever, saying, "Well, it could have been nice." That sounds about right. Sure, Tom was a tall, dark, handsome athletic charmer who was scary smart. But the choice was clear: My loyalty was to my dog.

The next day, Tom and Shadow had "the Talk." Based on expert advice at the time, Shadow ended up at the vet to be neutered. Two months later, Shadow and Ben still couldn't comfortably be in the same place. Tom's gesture had brought him back into my good graces, but the reality was that we had a big problem.

Tom and I had only just started dating, but we were already in counseling: dog counseling. We worked with a trainer, walked as a pack, and took the dogs on controlled expeditions together. It was my first serious foray into dog training, and I was hooked. It was interesting, it was fun, and it was rewarding. After months of careful interaction, it worked.

So, Tom and I got married.

That's us on our honeymoon with Kela, Shadow, and Ben. (What? People don't take their dogs on their honeymoon?)

We wanted to start off on an adventure, and Tom's career gave us the perfect opportunity. He took his African affairs expertise from Capitol Hill and turned it into a job with an American NGO supporting the new democracy under Nelson Mandela in South Africa. Our honeymooning little family — Tom and I, plus Ben, Shadow, and Kela — moved to Johannesburg for an experience that turned out to be extraordinary in just about every way. (Since this book is about dogs, I won't digress into stories about lions, elephants, and baboons, but boy, could I.)

It didn't take us long to notice that our house was just a few miles down the road from the South African Guide-Dogs Association for the Blind. Of course we visited, and we learned they were looking for "puppy raisers." We met the latest litter of squirming, jumping, cuddling yellow Labs. We figured that kind of charity work — socializing puppies, getting them ready for the training center — was right up our alley. We agreed to take a new baby, Piper, figuring there was no way this extra pup would feel a part of our own pack, so it wouldn't break our hearts to send her on her way later on.

We figured wrong.

Adored by all five of us, Piper quickly became a happy focus and a glue for our fledgling blended pack. A year later, when the Guide-Dogs Association lady came and took our darling, mystified Piper away, Kela howled for hours at the gate. It was devastating. With Piper gone,

it was just so quiet. We tried to rest in the good she'd be doing, but we couldn't help but think about how happy she was surrounded by our big pack. In my darker moments, I let myself picture the worst-case scenario: Piper sad and lonely, spending long days with a blind guy who didn't really care if he had a dog or a cane…

Two months later, out of the blue, the Guide-Dogs Association called and left a cryptic message. My heart leapt. I called back, and the woman explained that Piper's mom had developed epilepsy, and in case it was genetic, they had to remove the entire litter from training. Then came the delightful shocker: Since Piper couldn't be a guide dog, they were offering her to us, since we'd been her "puppy raisers."

Glee doesn't even begin to describe our reaction. I should note that in the intervening months, I had given birth to our first *human baby*, Grace, and still Piper's absence had loomed so large that it all hadn't felt quite right until just that moment.

With that magical phone call, the last, key ingredient to our original pack was delivered to us.

Ben, my soul-mate dog: my rock, my protector, my joy. Always at my side, both of us happy with just that. Even as our pack grew to include so many others, we both knew that he was mine and I was his.

Shadow, who took only a quick twelve years to mellow into a wonderful dog. During those first dozen years of barking and escaping, Tom's constant, loyal refrain was, "Even when he's a bad dog, he's a good dog." I was so busy with the kids in those years that I think I failed to notice much of that "good." However, in what we thought was Shadow's twilight, we adopted a new puppy, Zoe, and Shadow's positive side blossomed. Challenged with guiding the future of the pack, Shadow was reenergized. As he tutored puppy Zoe, he emerged as a calm, wise, dare-I-say deep leader. I will be forever grateful that he lived to be seventeen. Those extra five years utterly transformed my understanding of that beautiful soul.

Kela: Ethereal, wild, incredibly feminine Kela was out of this world. As Tom tells the story, when a dog trainer came to evaluate Shadow's puppies, he picked up Kela, took a moment, and finally said, "I can't rate her." It sounds nuts, but the guy was on to something. She was all-knowing. Whenever you'd glance at her, you'd notice she was already looking at you, with

impossibly intelligent golden eyes. When she'd run through the woods, I swear she didn't touch the ground. When our babies were on a rare crying jag, Kela would give us a piercing stare: *What is wrong with you that you cannot soothe this pup?* I'm quite sure Kela's babies never would have cried.

Piper: Delicious, snuggly, happy, friend-to-all Piper was perfect even at eight weeks — learning so quickly, effortlessly. By the time she was a year old, it felt ridiculous to put a leash on her because she was 100 percent responsive to my voice. We could literally bring her anywhere, and so for thirteen years, we did. She was nothing but sweetness and devotion.

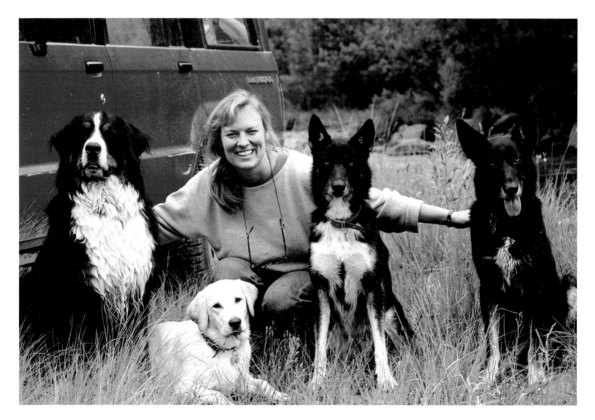

Hiking in South Africa with Ben, Piper, Kela, and Shadow

One of the most joyous things I've ever seen was the reunion of Piper with Kela, Shadow, and Ben when she got back from those two months at the Guide-Dogs Association. Many years later, when we had to put Piper to sleep at thirteen — the last of the old crew — we cheered ourselves up by imagining that exact same scene being replayed as Piper rejoined her pack and found herself right where she belonged.

We had a glorious, adventurous six years with those four dogs. We traveled, we trained, we hiked, we entertained — all with dogs in the mix. As we welcomed our two girls, the dogs guarded, taught, shared, and played with Grace and Claire. Those sweet, huge years did something. They were some kind of happy crucible. For our marriage, for our family, for this pack.

Crazy Dog Lady that I have become, I know that those four original dogs — long "gone" by now — influence every single day in this house. I can feel it.

And I like to think that, as 150 fosters and counting have lived with us, a beautiful little piece of Ben, Shadow, Kela, and Piper goes out into the world with each of them.

ODE TO JOY

We have joy on tap in this house, thanks to puppy fostering. Sometimes it comes in the form of a wide-open, trusting smile like this one from Apple Jack. Maybe it's a pup prancing around with a cup on his head, or a littermate surprised by her own backflip. Perhaps it's two pups racing to dig to the bottom of the water bowl.

Whatever it is, we've seen it a thousand times before, but it's mesmerizing all the same. Just two empty nesters now, Tom and I sit here laughing, realizing what a stroke of luck it is to have all of this life happening right under our roof.

"BUT...HOW DO YOU LET THEM GO?"

"But how do you let them go?"

People ask me this over and over.

There are flip answers I've learned to give — "I get rid of them before they're trouble!" "I don't, I just adopt their new families, too!" — but they're lies. I use them because the real answer is hard to say out loud.

We love them to pieces, these puppies.

It begins that first hour when — towel-wrapped after a bath, exhausted over all they've been through — they fall asleep in our laps. The bonding grows over the next days and weeks. We gaze into their eyes, they nestle into our laps. We laugh over their drunken walks, we lose sleep over their coughs. We are climbed on and gnawed. We gleefully witness the emergence of each distinct personality. When they snuggle into that warm spot just under our chin, sigh, and fall asleep...we don't move.

They trust us completely.

So truly...how do we let them go?

The real answer has grown from a slight flicker of a hazy thought during the first dozen dogs into an almost tangible aura in our house eight years and 150-plus fosters later:

We can let them go because this process fosters more than puppies. It fosters faith.

I am not someone who talks about that kind of thing. But here we are. It's unavoidable. These dogs have taught me an all-encompassing, supremely calming, take-your-breath-away-every-now-and-then kind of faith.

There is nothing quite like finding yourself sobbing in the car on the way to the shelter, throwing up a desperate prayer to a god you think it's ridiculous to pray to about your little problems given the horrors in the world — but throwing up that prayer anyway — because the fantastic, wide-open, trusting puppies you've been nurturing for five weeks are about to be adopted out to strangers, by strangers . . . and finding that your prayer has been answered in the form of people you couldn't have known, couldn't have found, wouldn't have predicted, showing up to love those dogs beautifully, perfectly.

That actually happened.

Then different versions of that happened.

When still more variations on that happened, something began to dawn on me.

I had a moment, about two years in, where I sat in my beloved yard, surrounded by my all-knowing trees, pondering these puppy souls and their extraordinary road. A thought crept in, slowly at first, gaining steam, until I was stunned with the simple truth of it: The universe is with me on this.

I am not someone who talks about faith, nor am I a crier. But when it comes to the particular subject — this one, so very particular subject — of these dogs, and how they end up here, and what happens in this house with them, and how they then go on, and with whom, and what happens after that to both the people and the dogs — well, I'm moved to both tears and faith.

So.

That's the real answer. But remember: If you overhear me telling somebody in the grocery store, who has just asked how I can bear to let them go, "I get rid of them before they're trouble!" please don't rat me out.

The truth is a secret, just between you and me.

THE REAL SAINTS

Inevitably, when I post about a new litter of foster puppies, somebody in my social media world says, "You're a saint." It is so generous, so well-intentioned . . . and it always makes me cringe.

Let's be clear: I'm the one who does the fun part of dog rescue. We who foster puppies (and there are loads of us!) get to spend our days in a happy, hilarious pile of puppy breath and snuggles. Not quite sainthood stuff.

However, those Facebook commenters are right that saints are afoot because we are surrounded and supported by them. If you ask me, here is the list of actual saints:

- SHELTER WORKERS: The people at underfunded rural shelters take in neglected, abandoned dogs every single day. They see the worst in people. They deal with animals who are scared, sad, and unhealthy due to neglect. With little money for care and no realistic hope of local adopters, most of us would be overwhelmed by the challenge in a few days. But there are folks who spend every day tirelessly working their connections to get these dogs into rescue — all the while dispensing kind, loving care to these displaced souls.

- **FREEDOM DRIVERS:** Every week, countless volunteers spend their free time driving one leg of a "freedom ride" that gets dogs out of bad situations and into rescue. The dogs are often filthy, with a stench that fills a car in three seconds flat. These folks don't get to enjoy the fun cuddles or see the happy ending, yet they show up, again and again.
- **RESCUE ORGANIZATION DIRECTORS AND ADOPTION COORDINATORS:** People start to work in rescue because they love animals, and they get so good at it that they have to spend their days in emotional, challenging interactions with humans. They face desperate pleas from shelter staff — "We're at our absolute limit! Please take this one!" — and since funding is scarce, they often have to say no. They fight for more humane laws, which involves contentious, lengthy battles for what is often just incremental change. In addition to that kind of torment, they have all the normal management headaches of a business but little, if any, of the compensation.
- **MONEY PEOPLE:** Do you think that adoption fee seems steep? The truth is it may not even cover the cost of rescuing your newly adopted dog. Of course, food and supplies add up, but medical costs are budget-busting. Vet checkups, heartworm tests, vaccinations, spay/neuter surgeries, and dewormers are standard. Then there are the dogs who are ill or need multiple surgeries. Every so often there's, say, the litter of puppies that comes down with parvo (a highly contagious virus that can quickly become deadly) and ends up draining the account of seven thousand dollars. Adoption fees help, but fundraising is what makes rescue feasible. The inexhaustible, inventive fundraisers who keep finding new ways to reach out to animal lovers — and of course to those good folks who click "donate" — are the ones keeping this entire effort afloat.
- **THE BRAVEST FOSTERS:** My personal heroes are the fosters who take in adult dogs who need medical or behavioral rehab. When you foster one of those, you know full well they will be with you a long time. They will inch further and further into your heart — all the while disrupting your life (and quite likely your furniture and perhaps your neighbors). The work is hard; the goodbyes are harder. Yet those brave people keep saying yes.

So, no, I'm not the saint in this picture.

When you examine why there's a need for all these good people to work so hard rescuing dogs, it's easy to get upset. The ways in which humans let dogs down are dramatic, mundane, myriad, and breathtaking. You can easily get filled with rage.

I don't let myself go there. Instead, I do what Mr. Rogers's mom told him to do when scary things happen: "Look for the helpers. There are always helpers." This book does have a few dogs who were treated poorly by a human. But in each case, about two dozen other humans stepped up to get that pup into a great life. One bad apple; two dozen caring strangers. The way I look at it, that's a great ratio.

How You Can Help

WANT TO PITCH IN? Contact your local animal shelter or rescue group and ask what they need.

WONDERING IF FOSTERING IS FOR YOU? Go to my website (www.puppypicks.com) for a bonus chapter on the "FAQs of Fostering." (You will also find puppy videos that go along with each chapter!)

LOOKING TO DONATE? Here are the fantastic groups whose pups are featured in this book.

HOMEWARD TRAILS ANIMAL RESCUE
www.homewardtrails.org

ANIMAL WELFARE LEAGUE OF ALEXANDRIA
www.alexandriaanimals.org

BIG FLUFFY DOG RESCUE
www.bigfluffydogs.com

ACKNOWLEDGMENTS

I wrote about these puppies because what was happening in our house was too big *not* to write about. However, these stories would still be in a messy folder on my computer were it not for a few key humans:

- The phenomenal women in my writing group — Elisabeth, Paige, Rosie, Susan, and Vero — who lent me their brains, their hearts, and the deadlines I needed.
- Joan Brookbank, a gem of a soul who plucked my book out of the ether and said yes. Her wise, kind shepherding — indeed friendship — is a delight. (I try to throw the phrase "my agent" into as many sentences as I can, because I still find it hilarious that I have one…)
- The amazing team of experts at New World Library who gave me the thrill of a lifetime by embracing the book from the start, and then making it better in every way.

There would be no book if there were no fostering, and I'm thankful to all the people who make it easy to say yes to each new puppy:

- The folks in rescue who do the hard part so we can do the fun part. (See "The Real Saints," p. 133.)
- The wonderful village of friends who drop off supplies, help socialize pups, and spread the word.
- The adopters who help me sleep soundly at night by loving these dogs so well, and sending the Crazy Dog Lady updates even years later.

Finally, the big stuff:

- I grew up in a house filled with warmth and laughter, and the love on every page of this book is very much rooted in the Gord family: my parents, Barb and Stu; and my siblings, Kris and Steve.
- Deepest, joyous thanks go to my pack: my husband, Tom; and our daughters, Grace and Claire. Their warm, funny, intelligent, generous, curious spirits make every single thing in life better.